LOST LEWISTON
IDAHO

ELEGIES AND BYGONE PLACES

STEVEN D. BRANTING

Published by The History Press
Charleston, SC 29403
www.historypress.net

Copyright © 2014 by Steven D. Branting
All rights reserved

Back cover: Photograph by George Poleson.

First published 2014

Manufactured in the United States

ISBN 9781.62619.617.9

Library of Congress CIP data applied for.

Notice: The information in this book is true and complete to the best of our knowledge. It is offered without guarantee on the part of the author or The History Press. The author and The History Press disclaim all liability in connection with the use of this book.

Unless otherwise indicated, all images in this book are in the public domain or are courtesy of the archives of the Nez Perce County Historical Society, located at 0306 Third Street, Lewiston, Idaho 83501. All rights reserved. No part of this book may be reproduced or transmitted in any form whatsoever without prior written permission from the publisher except in the case of brief quotations embodied in critical articles and reviews.

For faithful Shann, my partner at the oars on the river of time.

For my universally esteemed father, John Herbert Branting (1919–1980).

*His life was gentle, and the elements
So mixed in him that Nature might stand up
And say to all the world, "This was a man."
—William Shakespeare,* Julius Caesar

CONTENTS

Preface	7
Introduction: Our Past in the Present Tense	9
1. Having Left Nothing Done Halfway	13
2. Postcards from Our Fathers: Old Town	34
3. Piety Amidst the Dusty Promise	44
4. A Willing Shepherd Under No Compulsion	69
5. Postcards from Our Fathers: Normal Hill	85
6. The Passing Tribute of a Sigh	92
7. Tales From the Outskirts of Town	111
8. If the Glove Doesn't Fit	125
9. Cast Off This Aimless Burden of My Heart	129
10. Postcards from Our Fathers: The Orchards	139
Epilogue: As Through a Glass Eye	147
Index	153
About the Author	157

PREFACE

The archival contributions of DeLayne Whipple Brown (Vancouver, Washington) were invaluable assets to my research into the life of John Douglas McConkey.

I am indebted to Matthias Bertram (Bad Neuenahr-Ahrweiler, Germany) for kindly supplying letters posted from Lewiston by Peter Josef Ley, his second great-granduncle and an early Lewiston business owner, and to Dr. Stefanie Seewald (Leuphana University of Lüneburg, Germany) for her lucid translation of those letters.

My thanks go out to Rabbi Victor S. Appell, Union for Reform Judaism (New York, New York), for his input regarding canon law and its application to pivotal events in the lives of Jewish families.

As with the first two books in this trilogy, Mary E. White-Romero (museum curator, Nez Perce County Historical Society) made my access to the museum archives a seamless and productive task.

Portions of this book have appeared in different forms in *A Confluence of Doyennes*, *Idaho Yesterdays*, *Journey*, the *Golden Age*, the *History Teacher*, *Journal of the Association for History and Computing* and the *Western Historical Quarterly*.

To link the reader to additional content, parenthetical references are provided throughout this book to stories and photographs that appeared in earlier volumes of the Lewiston trilogy, such as *Historic Firsts* 34–36 and *Hidden History* 80–86.

Expenditures and costs for various projects have been listed in terms of their original outlays and what reasonably equivalent values would be today, as in this example for 1894: $2,500 ($66,000).

Introduction

OUR PAST IN THE PRESENT TENSE

An unknown love-struck poet poured out his heart for his "sister" (beloved) in New Kingdom Egypt (1550 BCE–1080 BCE).

> *My sister is better than all prescriptions.*
> *She does more for me than all medicines.*
> *Her coming and going to me is my amulet.*
> *The sight of her makes me well!*
> *When she opens her eyes, my body is young.*
> *Her speaking makes me strong.*
> *Embracing her expels my malady.*

William Shakespeare, Walt Whitman or Dobie Gillis could not have penned it better, and in that very fact lies the premise to this book: human nature unites all human existence, past and present. We are separated from that forlorn lover only by time, circumstance and, sadly, technology, which has always inflated a society's sense of uniqueness and created that cultural noise that promotes feelings of superiority of one generation over another. "Noise proves nothing," Mark Twain observed. "Often a hen who has merely laid an egg cackles as if she laid an asteroid."

In 2014, the Bowers Museum in Santa Ana, California, opened the exhibit "Soulful Creatures: Animal Mummies of Ancient Egypt." Those ancient people loved their animals, which were intimately associated with a pantheon of zoomorphic gods. One mummy was dedicated to ibis-headed Thoth and

INTRODUCTION

contained a letter from a man who was having a difficult time at work, certain that a co-worker was badmouthing him behind his back to his boss. The complainant wanted the god to intervene. Nothing seems to have changed.

One advantage to exploring the past is that it prevents us from feeling too self-important. Stephen Crane, the author of *The Red Badge of Courage*, experimented with brief verses, which he called "bitter little pills" and are considered today to be the precursors of modern poetry. In one example, Crane wrote:

> *A man said to the universe:*
> *"Sir, I exist!"*
> *"However," replied the universe,*
> *"The fact has not created in me*
> *A sense of obligation."*

Although I know my parents loved me, I have a suspicion that many of my childhood memories are false, filtered through their imperfect memories. Mother would relate how I was prone, as a toddler, to wander away from our home in a small Idaho town in the late 1940s. Being a busy parent with a babe-in-arms required ingenuity to corral this restless child. She took a good length of rope and tied me to a tree in the back yard. Of course, any good measure deserves a good counter-measure. As she was wont to tell, things became quiet behind the house one day. Investigating, she found me gone, having chewed the rope in two. By the time my father arrived home from work, she was a bit frantic. He calmed her and set out to find me, which didn't take long. It was a small town, you know. In the finding came a rude discovery.

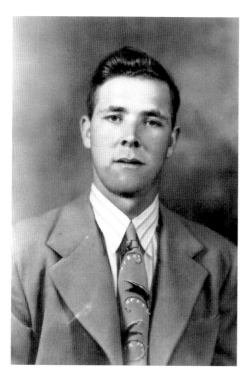

John Branting, circa 1945. *Courtesy of the Branting Archives.*

INTRODUCTION

His nomadic son was stark naked, dancing to the music of the jukebox in a local bar, with coins on the floor around me, scattered there by patrons who were delighted with my fox trot. I can remember my mother using the word "mortified" to describe my father's reaction, and my father was not one to readily show his emotions.

If any story will keep my ego anchored, this bit of life experience has most assuredly done so. The problem is: was the story so embellished, so garbled in the retelling, that by the time I heard it the account was more fable than fact, more faulty reconstruction than reality. Eyewitness testimony is notoriously inaccurate, even when people see the same event from the same vantage point. Anonymous once opined, "History books that contain not falsehoods are extremely dull." Lives are much the same. Much of history is gossip made respectable by the passage of time. Parents have always been searching for wandering children.

The reality of the present is little different from the reality of the past, and all of us live in the past. I am not speaking about nostalgia or people who are stuck in the '60s, '70s or '80s. Anyone who longs for the good old days has never spent a Lewiston August without air conditioning, but that's not my point. Neuroscientists have actually calculated that our consciousness lags eighty milliseconds behind actual events. What we sometimes call "real time" isn't so real after all. It's almost as though "now" does not exist.

Try a little experiment. Touch the top of your head and your knee at the same time. You might think the actions take place simultaneously, but it actually takes longer for the signal from the knee to reach your brain than it takes the signal from your head. The brain compensates for the eighty-millisecond time gap in the information assembly line that continually runs in your head.

Being a realist, I have no science-fiction illusions. As much as I may desire to experience it—and I suspect you do as well—time travel into the past will never be possible. Heraclitus, the Greek philosopher of the fifth century BCE, knew that change was central to the existence of the universe: "You never step into the same river twice." Even H.G. Wells only sent his Time Traveller into the inventor's future and back to the present. We *are* time travelers, bound at one point in the stream of time; and yet no one, not even the "patriarchs of an infant world…the wise, the good, fair forms and hoary seers of ages past," has escaped the consequences of the past. Learning history is easy. Learning the lessons of history proves to be more difficult.

So much of what history, even local history, can teach us has been lost to inattention, a type of blindness in the guise of an "invisible gorilla." In a 1975 study, researchers asked participants to perform a very simple task:

INTRODUCTION

watch a short video and count either the number of times a ball was passed among a group of people or the number of the times the ball touched the floor. At a point in the video, a woman walked through the scene either dressed in a full gorilla suit or carrying an open umbrella. The test subjects were very adept at keeping count, but 50 percent of the participants never saw the gorilla or the umbrella. Their minds had become so focused on the tasks that they were now "inatentionally blind." Magicians throughout history have taken advantage of misdirection.

Although the field of human vision extends about 180 degrees, the clear field is only about 40, with color fading as it expands. Movement dominates our peripheral vision. People who love history develop owl-like swivel perception, detecting the inevitable connections forged among people living in any community. In his book *Liberation Management*, Tom Peters noted that "the interesting 'stuff' usually is going on beyond the margins of the professional's ever-narrowing line of sight." The fabric of time has an infinite warp and weft, to which every living person has contributed. We are enmeshed in that fabric just as firmly as every person who appears in this book. Their lives deserve no less a proper and well-written telling than our own.

Henry Kissinger related in a memoir how he dealt with new officers in the State Department. When they submitted briefs for his review, he would not read them. The documents would be returned with a notation: "Is this the best you can do?" Any staff who received that reply went to work refining his report, enhancing his presentation and confirming facts. Resubmitted briefs got the same treatment. This tactic battered many egos. Briefs would take on the look of a doctoral thesis. Kissinger would then ask the staffer in person, "Is this the best you can do?" When he got the reply "absolutely," Kissinger would then say, "Good. Now I will read it." I hope you will agree that I have done justice to the people and places that appear here.

One final note: when you are reading a story, forget for a moment who you are now and think of yourself as an eye-witness to what you read—a friend, the man on the street, a guest at the party, a hammer-swinger, a neighbor or the rowdy little kid hanging out on the corner.

Learn to think of the past in the present tense.

1
HAVING LEFT NOTHING DONE HALFWAY

As the builders say, the larger stones do not lie well without the lesser.
—*Plato*

Stroll down any street in any town or city in man's long history and study the structures designed and constructed to meet the local needs, terrain or building materials. "Designed" is the operative word, but its meaning is obscured by modern perceptions and building codes. The word "architect" is derived from the Greek *architekton* and the Latin *architectus*. Those words did not describe someone like Le Corbusier, I.M. Pei, Eero Saarinen or Kirtland Cutter.

In his *De Architecturas* (circa 20 BCE), Marcus Vitruvius described the master builder. He would have a command of written languages, drawing, arithmetic, geometry, surveying and even optics. Master builders were even said to have a mastery of music, using the tones produced by stressed ropes to calculate the correct tension in hoists and other strung machinery. Such men were said to possess *ingenium* (ingenuity) and were called *ingeniators*, from which word we would eventually get "engineer." The word "engine" meant the product of genius and ingenuity. Those craftsmen stood above all other trades. Lewiston was blessed with such a man for more than three decades.

Harry Thurston Madgwick was born in Derby, England, in 1858. Nothing is known about his life as a boy there, other than that he had a brother who immigrated to the United States, possibly about the same time as Harry went to California in 1876. Harry did not remain long,

arriving in Lewiston in 1879, when Raymond Saux was completing plans to build a new hotel, the Raymond House, on the corner of Fifth and Main Streets (*Hidden History* 104–105).

A tall, rawboned young man with big feet, Madgwick bid on Saux's project and won the contract, raising a three-story edifice that was the centerpiece of a city trying to throw off the effects of the "Somber Seventies." Visitors later related that the Raymond "was considered the finest in this territory." In 1879, Abigail Scott Duniway, famed Oregon women's rights advocate and publisher of *The New Northwest*, reported that "the Raymond House is a new hotel, kept by a hospitable and worthy French lady [Augustine Saux], who has made our visit exceedingly pleasant." The June 1880 federal census listed Harry as a resident of the new hotel, along with Robert Schleicher (*Historic Firsts* 52–54) and Edward B. True, who completed the 1874 survey that finalized the town site status for the city. Madgwick quickly acclimated to his new home. On March 6, 1880, he was inducted into Masonic Nez Perce Lodge 10, but more on that topic later.

The Raymond House generated several interesting stories over the years. Among them is a tale of Lewiston pioneer John Silcott, who married Nez Perce Chief Timothy's daughter Jane, in a ceremony conducted by the famed missionary Henry Spalding. The first territorial legislature had banned "marriages and cohabitation of whites with Indians, Chinese and persons of African descent," but no one in Lewiston thought anything of the union. However, when John's sister visited from Kentucky, he put her up in the Raymond, claiming that his home was just a "bachelor cabin" and unfit for a lady of his sister's tastes. He was the perfect host, taking her on buggy rides and wining and dining her at the hotel before sending her home. She never learned about Jane.

Charlotte Kirkwood recollected standing on the porch of the Raymond as she watched a company of cavalry escorting Nez Perce tribal members back to the reservation.

> *Among others, there passed an old savage, Scar-faced Charley, who, fearing that he might be shot, and wishing to conceal his identity, had tied a handkerchief over his face. There was quite a feeling of bitterness displayed. I heard one man on the street call out, "Ben, where is your gun?"*

Impressed by Madgwick's craftsmanship, Robert Grostein commissioned Harry to build him a home worthy of a wealthy Idaho businessman in 1882. That home rose in what is now the 600 block of Main Street and was

said to be "one of the finest residences" in the city (*Historic Firsts* 23, 114). The *Lewiston Morning Tribune* later called it "one of the most pretentious in the west." After Grostein's death in 1907, undertakers J.O. and C.J. Vassar purchased the house and remodeled it as a funeral home. In July 1912, workers laboriously bisected the building to move it and found that residences built by Madgwick "emulated the strength of Gibraltar." Crews who razed several of his homes in later years said that the square-headed nails held wooden beams together like iron bolts. The flooring had been laid like so much concrete. "The exteriors were nailed a dozen times more than seemed necessary."

Madgwick expanded his commercial projects in 1882 to begin work for brothers Charles and Dennis Bunnell. Charles came to Lewiston in 1862, after operating a tinware and stove store in Portland, Oregon, and established the city's first hardware store. By 1872, his assets were listed as $5,000 ($100,000), making him one of the wealthiest men in Nez Perce County. The brothers wanted a brick-and-mortar hardware store, not the stick-and-frame sort that was so common and prone to fire. Madgwick delivered with one of the city's first brick buildings, described at the time as "one of the neatest and best arranged stores found this side of Portland." The store was even advertised as "fire-proof." That claim went up in smoke on May 8, 1908.

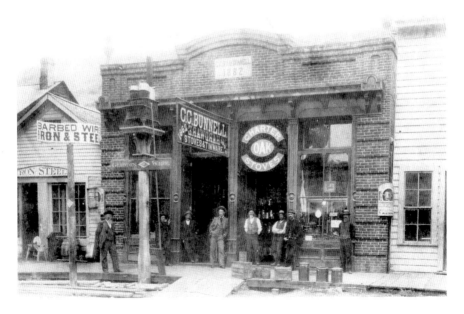

Bunnell Building, circa 1884.

LOST LEWISTON, IDAHO

In February 1885, Madgwick's collaboration with Robert Grostein assumed greater proportions when it was reported that Harry had ordered 400,000 bricks to complete a new store on the west side of Second Street, across the road from the old Grostein and Binnard Opera House (*Historic Firsts* 73).

Many private homes would follow over the next twenty years, including those for Seraphin Wildenthaler (Eighth and Main Streets, circa 1894), Benjamin Morris (Fifth Avenue at Fifth Street, 1896) and Hazen Squier (Ninth and Main Streets, before 1899). He remodeled the William Kettenbach home, on Main Street, into what was called "one of the showplaces of Lewiston and architecturally perfect" (*Hidden History* 101–102). Sadly, only the Grostein remains. The Morris home was so well constructed that the workmen had to use the largest crowbars they could find to dismantle it in December 1934. The wood was reported to have been as good as the day it was installed. That being said, Madgwick's Lewiston legacies would not depend on private homes, even during the years in which residential construction reached new levels.

Madgwick's business was diverse. His newspaper ads were common sights, listing him as a "dealer in shingles, lime and brick." The June 1900 issue of the *Normal Quarterly* (Lewiston State Normal School) prominently advertised him as being a "contractor and builder." The connection to the Normal will be soon come evident.

In 1883, when John P. Vollmer was ready to build a new headquarters across the street from the Raymond House for his expanding business empire, he came to Madgwick. A two-story brick commercial building designed in the Renaissance Revival style, the Vollmer block rose over the winter of 1883–1884 as a general merchandise store with offices on the second floor. Delays were common. Low water on the Columbia and Snake Rivers hampered steel beam shipments, and supplies had to portage around the Celilo Falls near the Dalles. Praised as "the finest building this side of San Francisco," the structure first housed the J.P. Vollmer Great Bargain Store. The First National Bank of Lewiston originally occupied the west storefront (*Historic Firsts* 79–80). The assertion that famed architect Kirtland Cutter designed the building cannot be true, as he did not arrive in the region until after the store was completed. The building now houses Lewis-Clark State College's Center for Arts and History.

Political events would now begin to impact Madgwick's projects. The carving out of Latah County from Nez Perce County, in May 1888, precipitated a move by Lewiston civic leaders to upgrade the courthouse, which at the time was the old Luna House Hotel, a shabby relic of early

Benjamin Franklin Morris home (exterior and interior), circa 1910. *Courtesy of Charlotte Westervelt Bispham.*

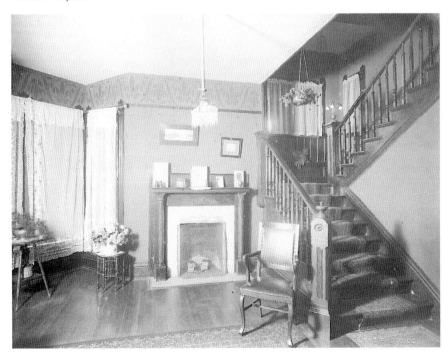

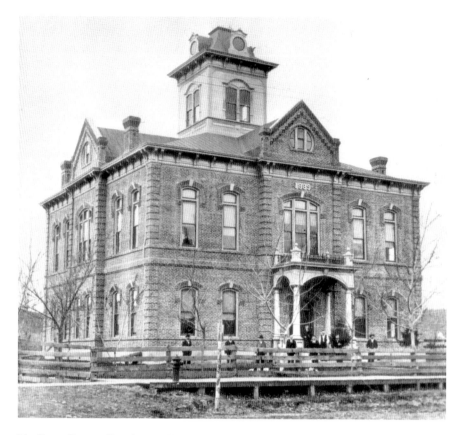

Nez Perce County Courthouse, 1897.

unregulated building methods (*Hidden History* 80–86). Moscow was constructing an edifice befitting its new role as county seat. Lewiston would have to follow suit, and Harry Madgwick was the man for the job.

Many sources attribute construction to William B. Cooper, another Lewiston contractor who had built the city's first large public school (*Historic Firsts* 86). However, the weight of evidence points to Madgwick. The November 4, 1934 issue of the *Lewiston Morning Tribune* described the project as the "crowning achievement" of his career. Among his construction crew was George E. Erb, later a trustee of Lewiston State Normal School, mayor and a longtime judge in the city. A twenty-two-year-old Erb arrived in Lewiston in 1889, flat broke and looking for work. The site of the courthouse was not a popular one. Many residents complained that it was too far out of town, although the location was actually within the original city limits.

Madgwick's many ventures necessitated a suitable and central base of operations. The January 1891 Sanborn map of Lewiston shows his lumberyard, office, lumber shed and carpenter shop taking up a large portion of the block on Main Street, between Seventh and Eighth Streets, behind the Universalist Church and the Wildenthaler home. The depot and production shop were busy with his next projects. William F. Kettenbach Sr. received a charter for his Lewiston National Bank in August 1883 but had not invested in a new building to house it. There was also the need for a new plant for his Lewiston Water and Light Company.

Kettenbach left school in Indianapolis at age sixteen and lit out for the western frontier, where he was in the government service, acting as a scout with Kit Carson and Buffalo Bill. Bankrupted by the financial collapse in 1877, he came to Lewiston in December 1878, working first as an agent for the Oregon Railway and Navigation Company. By 1890, his fortune secure, he was intent on a building to surpass anything in the city. Constructed at the corner of Fourth and Main Streets over a three-and-a-half-month period in 1891, early newspaper accounts describe the bank's almost-white structure as "the marvelous magnesia" building. In 1899, it was praised as "the best bank building in the state, the rental from its offices bringing the bank $400 ($10,000) per month." Madgwick was not the original contractor. When that firm proved unable to complete the structure, Harry finished the beautiful bank, which would remain a Lewiston landmark until June 1965, when it was razed to make room for a new financial building (*Hidden History* 76–78). The quality and sturdiness of the construction led him to take a shortcut that would not be discovered until the old bank fell to the wrecking ball, but that is also a little ahead of our story.

Designed by San Francisco engineer Homer Bloomfield, the city water plant took shape in 1890–'91, more than two miles upstream on the south bank of the Clearwater River, near the Kettenbach grain warehouses. Lewiston's water system was a private enterprise, at the time under a twenty-five-year franchise. The plant had a capacity of 1.5 million gallons and went into operation on May 1, 1891. It was not long before the city was objecting to the high rates Kettenbach's company was demanding. Free enterprise was proving to be very expensive. In early 1900, Thomas Cooper, the owner of Nez Perce Machine Works and supposedly an "expert" in such matters, was called in by the city to assess the value of the company. The city wanted to buy out a controlling interest.

Cooper's findings did not sit well with the stockholders, and they refused to sell at the value he placed on the company. The city council reacted by

LOST LEWISTON, IDAHO

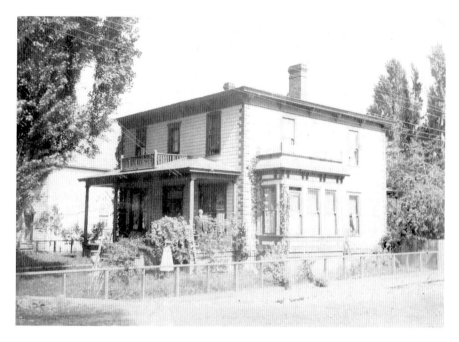

Seraphin Wildenthaler home, circa 1900. The Universalist Church (then the G.A.R. meeting hall) appears in the background. *Courtesy of Doug and Lorna Marsh.*

dropping the domestic water rates by more than 25 percent. The company unsuccessfully sued. In the meantime, and by the vote of residents, Lewiston issued $80,000 ($2.2 million) in bonds. Kettenbach threw in the towel in April 1900, and the city took over the operation of the water plant, which sat where the current 1920s plant now stands.

Harry's projects did not keep him from serving a term on the city council in 1893–94, but the years 1895 and 1896 would be a particularly busy period for Madgwick. Two major contracts would be planned; another would fall into his lap like the Lewiston National Bank building. The projects would place a strain on the local supply of building materials. *The Clay Worker* (July 1896) relayed a note from Madgwick to say that "very little brickmaking is being done this season." He would soon need them by the hundreds of thousands.

The Idaho legislature had created Lewiston State Normal School in January 1893. The Lewiston city council donated ten acres from a proposed city park south of town, but the financial Panic of 1893 paralyzed the American economy. Although the legislature eventually issued bonds for construction, the progress toward completion was less than smooth.

ELEGIES AND BYGONE PLACES

After the foundation of the administration building was prepared by local contractor Joseph Terteling, the contractor hired to raise the classroom and administration building got cold feet, fearing that he would not be paid for his work given the unstable economic conditions in the mid-1890s. As a result, when the new school's first president, George Knepper, arrived in Lewiston on November 1, 1895, he found what looked like a stone fence enclosure where the building was supposed to be. Knepper was soon calling on Madgwick for help. Madgwick assumed the contract and set his crew of eighteen craftsmen to their tasks. He ambitiously forecast completion by January 1896, but that was optimism speaking louder than reality. Quite frankly, Madgwick had overextended himself. On May 25, 1896, Knepper was finally able to open the building for a community reception. By early June 1896, it had become the first brick-and-mortar structure on the plateau above the old city, an area that became known as Normal Hill.

Madgwick no doubt beamed with pride when, on June 3, the new campus of Lewiston State Normal was dedicated. Idaho governor William McConnell and his staff attended the festivities, which started at 9:00 a.m. and ran all day long. Led by local military leader Edward McConville, a parade stretched for two miles, highlighted by three bands and two military companies. The military review that evening was attended by 1,500 people—more than half the population of Lewiston at the time. The city was delighted and had Harry Madgwick to thank for much of it. Schools would soon be a major portion on his construction schedule.

The Sisters of Visitation purchased a plot of land on Normal Hill, in January 1896, and contracted Madgwick to construct a school for girls southeast of the old cemetery (*Hidden History* 21). Called the "Visitation Academy," the brick building was the second large structure to arise on Normal Hill, after the normal school. The academy opened in 1897, with as many as sixty girls attending. In 1905, the Sisters of Saint Joseph took over operation of the building and renamed it Saint Stanislaus School. On November 3, 1935, the school burned to the ground, and all of the early records were lost. All three city fire trucks were called to the blaze, but the buildings, which included the Knights of Columbus Hall, were already engulfed. Only a lack of wind kept the fire from spreading to Saint Stanislaus Church. Losses amounted to $25,000 ($420,000). A new school was quickly planned, constructed and dedicated in 1936.

By 1898, the public school at Tenth and Main Streets was in desperate need of renovation. A bond election approved a levy to raise $15,000 ($410,000). The old "Lewis and Clark Public School," as it was then called, had become

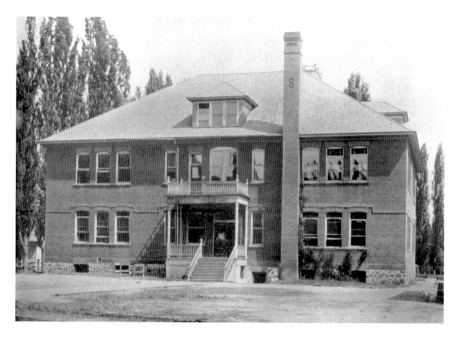

Lewis and Clark Public School (later known as Whitman), 1910. *Courtesy of the Lewiston High School Archives.*

overcrowded because of the additional high school classes being taught. Lewiston High School graduated students after grade ten, at the time. The new school, which many people still remember as Whitman Elementary, was dedicated for use as a high school, to which a third year was added in 1900 (*Historic Firsts* 85–87; *Hidden History* 28–34). The building served Lewiston students for fifty years and was razed in 1950 to make room for a new supermarket.

Lewiston's Main Street was quickly assuming a uniformly brick façade, and that took money—lots of it. Fortunately, many Lewiston residents had deep pockets. One of them was Charles Francis Adams, a Boston financier, descended from two presidents. Adams invested $1 million or more in Vineland (now Clarkston), financed the erection of the original interstate bridge, built a home on the north side of the Clearwater overlooking Lewiston and now wanted to invest in Main Street property. Over the summer of 1899, Madgwick built a $14,000 ($400,000) structure for Adams that housed many businesses over the years, including Lewiston Water and Power Company, Thatcher and Kling's Stationery and the offices of Dr. Susan Bruce, one of Lewiston's most prominent physicians (*Historic Firsts* 119–121). However, Adams' investment strategy came with some conditions for the city.

On December 10, 1899, he wrote, in a scathing letter to the city council: "I'll not spend another dollar in Lewiston until your damned streets are fixed up." Adams was responding to a movement by local merchants to pave Main Street. Lewiston businessman R.C. Beach lamented, "I am alarmed for my health. I want something to be done that will rid us of the mud and the stench of Main Street." Paving of the street would not begin until 1909, but that did not stop entrepreneurs from raising storefronts, using Madgwick as their contractor. His superior craftsmanship would again bring him another contract for which he had not been the primary candidate.

The close of the 1890s found Madgwick involved in the construction of buildings for two of Lewiston's wealthiest businessmen, Christ Weisgerber and Seraphin Wildenthaler. Weisgerber's first brick building on First Street replaced the original frame brewery built in 1879 but was now too small and limited to keep up with the thirstiness of a town that had grown into a city (*Historic Firsts* 30–32). Weisgerber approached Madgwick in 1899 with plans for a modern three-story structure that would hold a bottling plant and machinery for artificial refrigeration, increasing the output of the plant from fifteen barrels a day to fifty. The result was a building that produced beer for less than fifteen years, as the county went "dry" in 1913.

Wishing to expand his baked goods business, Seraphin Wildenthaler purchased property a block away from the brewery. Madgwick raised a two-story Romanesque Revival–style building, in 1899, that still stands and once housed a sausage factory and Orville Norberg's Lewiston Grocery. Norberg made four deliveries each day in a black carriage pulled by matched black horses. Lewiston State Normal School purchased his residence in 1925 to serve as the college president's home, a role it still plays.

David Dent and Clayton Butler were longtime Lewiston druggists in need of a secure and modern building. A graduate of Danville Normal (Virginia), Dent came to Idaho in 1880 and began teaching school, arriving in Lewiston in 1884, when he went into the pharmacy business with Samuel Isaman and Butler. The Dent and Butler Building began to rise in 1900, under Madgwick's supervision, in the gap between the Vollmer Building and the Lewiston National Bank.

Designed by architect Ralph Loring, the building was a three-story brick commercial structure, again modeled in the Renaissance Revival style. Still standing, it has a cast-iron façade, fabricated in Spokane in 1899; decorative brickwork that forms pilasters; triangular insets; and a parapet with pediments. The United States Signal Corps (the forerunner of the National Weather Service) and Lewiston's first telephone exchange would have

offices on the upper floor. A city councilor in 1897–98, Dent served two terms as city treasurer and four years as treasurer of Nez Perce County (1891–95). Butler would be a city councilor in the 1890s. It is here that the demolition of the Lewiston National Bank uncovered what seemed, to the demolition team, to be a little hubris on Madgwick's part.

As the shell of Dent and Butler building took shape, Madgwick saw that the quality of the east wall of the Lewiston National Bank far exceeded his expectations. He might have begun to reason: why add another wall? Why not just attach the new building to the existing one? In 1899, there was no Universal Building Code. For decades thereafter, rumors persisted that Madgwick had not constructed a west wall to the Dent and Butler. The rumors were left unconfirmed, until the dust settled in June 1965. There was no separate wall, just lath and plaster. The Dent and Butler had only three exterior walls of its own. Had Madgwick done this sixty-five years before on his own volition and knowingly endangered the integrity of both structures? In 1965, people certainly thought so, but the evidence buried in the minutes of the city council proves otherwise.

Beginning in early February 1900, the council voted on several motions relating to the Dent and Butler building. The partners were first granted permission to occupy a part of D Street with a temporary store while construction got underway. On March 29, 1900, the council reconsidered Ordinance 203 (passed August 18, 1896), which set the fire limits within the city and established regulations concerning adjoining structures. On that evening, a resolution was adopted granting Madgwick permission to use the east wall of the Lewiston National Bank as the west wall of the Dent and Butler, the council ruling that the project was "in substantial compliance" with city laws. One must wonder whether Loring or Madgwick's reputation trumped common sense. A new wall was hurriedly constructed in 1965 and remains the legacy of a shortcut approved by the city that might well have proven disastrous.

Johann D.C. Thiessen was one of Idaho's most successful sheep men, but when he arrived in Lewiston on November 10, 1876, he had fifty cents in his pocket. After serving a term as county deputy sheriff, he entered the cattle business, turning to Merino sheep in 1889. The high tariffs on wool made his herds very valuable that first year, bringing him $30,000 ($780,000) at market. The Thiessen "mansion" once sat at the base of Twenty-first Street. Among his other holdings in the city was a lot at the intersection of Fourth and Main Streets, what many people called "the Old Corner," and it was at this site that Thiessen asked Harry Madgwick to construct a three-story

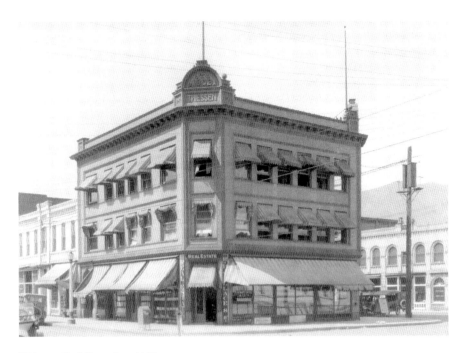

Thiessen Building, circa 1920.

office and storefront building over the winter of 1901–1902. For many years, The Silver Saloon was located on the first floor and was described as "the most elegant watering trough" in Lewiston. The Lewiston Business College occupied a floor of the Thiessen block for decades. The building was razed in 1965, along with the Lewiston National Bank.

During the construction of the Thiessen Building, Madgwick was approached by Albert and Eugene Alford to build a new home for the *Lewiston Morning Tribune*, which had been publishing out of rented facilities since September 1892 (*Historic Firsts* 99–100). The Alford brothers had purchased a lot of Fourth Street, land that was once owned by Welsey Mulkey, a pioneer Clearwater ferryman and sawmill owner in the 1860s. The building Madgwick completed at 0213 Fourth Street was a fifty- by one-hundred-foot brick structure with a full basement. On December 3, 1909, the structure was nearly destroyed by a fire that began in the basement pressroom. The building was insured (unlike many structures at the time) and rebuilt, serving as the home of the *Tribune* until 1961. The location is now a parking lot next to the new Lewiston City Library.

You have heard the expression "no job too small." It seems to have applied to Madgwick. In February 1903, he repaired the instrument shelter for the

weather station at the Dent and Butler building and was paid $38 ($975). Remember Thomas Cooper, who was involved with the city takeover of the waterworks? Cooper sold his machining business at Seventh and Main Streets to a group of partners, which included Madgwick, who then founded Lewiston Foundry and Machine Works. He would now have more control over metal ornamentations for his buildings.

Madgwick's business came under scrutiny in 1903, when the federal Comptroller of the Currency complained to the officers of the Lewiston National Bank concerning the amount of debt they were carrying for him. As with all honest men, his reputation came to his rescue. George Kester expressed the bank's position on the matter in a letter dated July 7, 1903:

> *H.T. Madgwick is an extensive contractor and builder and a greater part of his indebtedness to us in one way and another tied up in building contracts. This indebtedness has run along for some time, but as fast as he gets one set of contracts closed he has as many more on hand. We consider the loan perfectly good and could close it out at any time but it would place Mr. Madgwick in a position that would interfere with his business, besides that he is working out with us some all the time and it will not be long until his margins will be applied to pay up this indebtedness…The man Madgwick is perfectly honest, and will work out every dollar.*

As noted in *Hidden History* (76–78), the bank would soon have more pressing problems and its own reputation to salvage. In the meantime, Madgwick moved on to the construction of more schools.

The *Lewiston Morning Tribune* (1902) reported that "arguments in support of the movement were directed at the poor condition of the old wooden building at the Whitman School site." Robert Wright, Lewiston's superintendent of schools, was actively campaigning for expansion in the wake of increased enrollment. A bond election in 1903 raised $35,000 ($600,000) to construct a twelve-room school at a new campus above the flood-prone Clearwater flats on Main Street. Christ Weisgerber sold the school district several parcels at the top of the Thirteenth Street grade, for $3,750 ($100,000), within weeks of the election. The design of the school was ready, and Madgwick's masons and carpenters set to work, completing the building in time for the opening day of the 1904 school year.

As the new school took shape, Madgwick was committed to two major projects in Pioneer Park (what was then call the Fifth Street Park) and on Main Street. The Idaho State Constitution stipulated that the Supreme

ELEGIES AND BYGONE PLACES

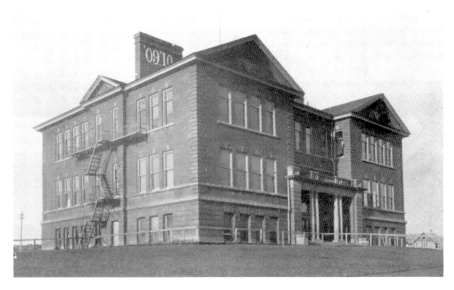

Above: Lewiston High School, 1910. *Courtesy of the Lewiston High School Archives.*

Below: Lewiston High School, circa 1906. *Courtesy of the Branting Archives.*

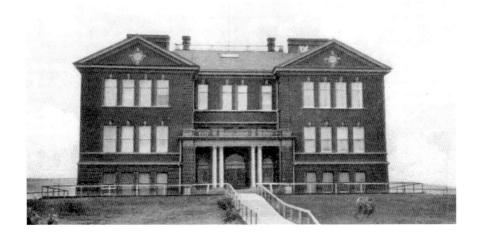

Court must sit in session at key sites around the state during each term. In 1903, the legislature authorized the completion of a building in Lewiston to house a courtroom and library for the justices when they heard cases in this region of the state. Madgwick was chosen as the contractor for the design.

The one-story Gothic-style building measured forty by seventy feet. The main floor contained a courtroom, judges' chambers, the library, a vestibule

and bathrooms. Madgwick spared no attention on the details of the building. Upon its opening, the *Lewiston Morning Tribune* extolled its features:

> *The vestibule is finished in hard rubbed quarter sawed oak, oil finish, the walls and ceilings being painted—the ceiling a rich yell* [sic]*; the walls above the door facings, a rich red and below, a beautiful green. The courtroom is finished in quarter sawed oak; heavy beam ceilings; handsome bench and tables made especially to suit the design of the room. It is kalsomined similar to the Masonic temple building, and is conceded by all who have visited it, to be a gem in beauty and is quite striking in its simple massive art. The library is finished in curly fir, hand rubbed, oiled and stained to match the dark oak of the courtroom. The cases in the library are built into and under the plastered wall, with spaces for busts and proper ornamentation for such a room. The large window seats in the east and west, and the deep finish of the woodwork, makes of this room a library which is seldom excelled. The walls and ceilings are tastefully kalsomined—walls in rich red and ceilings in standard yellow.*

The building and its accommodations for the court were said to be "one of the finest in the northwest." A full basement housed bathrooms and ample areas for the storage of documents and served as a supplemental library room. At the time, serious consideration was given to adding an apartment downstairs for a student at the Normal, who could act as caretaker. Local attorney Susan Henderson West served as the court's clerk for many years (*Historic Firsts* 107–108). Madgwick built her family home as well.

In August 1951, the four-thousand-book collection and shelves were removed and placed in the remodeled courtroom at the county courthouse on Main Street. The building, which had been returned to the county a few years previously, was sold at public auction and has been used by various congregations as a church since then.

When the Masonic temple on First Street (*Historic Firsts* 35) burned to the ground on September 27, 1904, along with many of the other structures on the block south of the Weisgerber brewery, the lodge lost most of its documented history, which dated back to the 1860s. Ironically, the Masons had a new three-story temple at 855 Main Street, but the membership had not fully moved its records into its portion of the new building. Why?

Nez Perce Lodge 10 had been endeavoring, since at least 1898, to build a much larger structure. The temple on First Street was actually a converted agricultural implement store, with the lodge facilities occupying the second

floor. Chester Coburn, the lodge's first high priest, had donated the space in the 1870s for meetings. A growth in membership rendered the old lodge unsuitable. In April 1883, Lewiston became home to the state's first Scottish Rite Masonic lodge, which might have been one of the first two to be chartered west of the Mississippi River. Idaho's first Thirty-third Degree Mason was Lewiston's Alfred Damas in 1899. In January of that year the lodge approached the city council to purchase property in the old cemetery. However, the city had other plans for the land (*Historic Firsts* 102–103). The project stalled until December 1903, when the lodge bought the deed to the old Jasper Rand estate at Greeley (now Temple Lane) and Main Streets and razed his grand old home. Rand died in 1898, after a long career as a Lewiston attorney, judge and mayor.

After settling on a design, the lodge hired Madgwick to erect a combination lodge and theater for $62,752 ($1.6 million). The first floor of the Italianate Classical Revival–style structure was dedicated to a theater with a total seating of 853 on the main floor and in the balcony. A large banquet room took up most of the second floor, with the third floor dedicated for the sole use of the lodge.

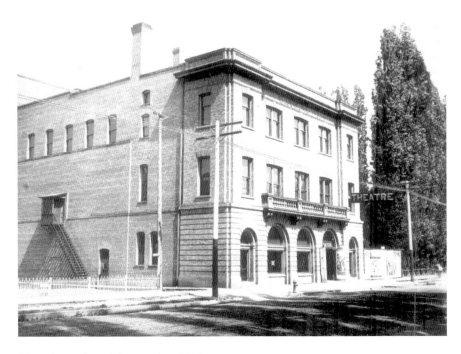

Masonic temple and theater, circa 1907.

In the rush to get the theater ready for its opening performances on June 29, 1904, the lodge continued to meet at its First Street site. Time and unforeseen events overtook them. Under the leadership of Isaac Binnard, son of Lewiston pioneer Abraham Binnard, the theater's opening was a huge success. Isaac went on to open the Liberty Theater, which remained the premier motion picture venue in Lewiston for decades.

The Temple Theater continued to prosper for decades, featuring appearances by, among many others, evangelist Aimee Semple McPherson and vaudevillian Stan Laurel. The Idaho Medical Society held its annual conference there in October 1904. The famed silent epic *King of Kings* debuted in Lewiston at the Temple Theater, as did *Snow White and the Seven Dwarfs*. Many people remember the boxing matches held there. In a surprising footnote, it was the site of a meeting of the Knights of the Ku Klux Klan on September 23, 1924. Why surprising? As you will learn in chapter three, the Binnards were Jewish.

The Weisgerber Building was the first truly modern building in the city and was the largest structure in downtown Lewiston until the Lewis-Clark Hotel opened in September 1922 (*Hidden History* 115). The site had been the location of the Charles Kress jewelry store and the city's post office. Weisgerber had begun purchasing property in the area of Fifth and Main Streets in November 1877. Working from a Kirtland Cutter design, Madgwick's product was superb, and tenants were lined up months before the building was ready. After the structure was destroyed by fire on March 1, 1994, the lot sat vacant. Lewiston again lost one of Harry's finest creations. Many wanted the site dedicated as a small park, but support waned. In 2006, Lewis-Clark State College opened Clearwater Hall, a new dormitory, on the site.

With so many projects underway at the time—the new high school, the Idaho Supreme Court Building, the Temple Theater and the Weisgerber—one cannot help but be impressed by Madgwick's management ability and the skills of his crews, who were all almost immediately involved with three new major buildings.

Madgwick ran afoul of local statutes in the summer of 1905. Fire partially destroyed the Adams block, and the agent for the building wanted repairs made. The city would not issue a building permit. Madgwick and three of his carpenters ignored the city and began work. They were promptly arrested. A suit over the constitutionality of the so-called fire limit case ensued, but by the time the court upheld the ordinance in November, "the entire difficulty [had] been compromised and satisfactorily settled."

ELEGIES AND BYGONE PLACES

By the turn of the twentieth century, the corner of Third and Main Streets had become a shabby vestige of old Lewiston (*Hidden History* 129). Although Dr. John Moxley had replaced an older structure with a brick building, it was now outdated. Moxley partnered with John M. Fix and Hazen Squier, fellow local business leaders who wanted to expand. The men commissioned plans for two buildings to nearly fill the block between Second and Third Streets, and Madgwick received the lucrative contract. Construction went smoothly, with the buildings ready for business by early 1906—but that is not the whole story.

Matthew Scully was none too happy with the new buildings under construction, and his opinions were not based on the architecture or Harry's workmanship. Scully had recently erected a building near the west end of the block, based on the 1874 survey drawn up by Edward True. He contended that Squier, Fix and Moxley were now constructing buildings that were too long, by four feet, to be exact. He sued. After losing in district court, Scully appealed in a case that made it all the way to the United States Supreme Court.

On November 29, 1909, in the case of *Scully v. Squier*, the Court ruled the Lewiston's original 1874 survey was in error, and that True had, without authority, changed the dimensions of lots in Block 24, cutting off those four feet from lots along D Street, between Second and Third, where the parking lot for the Lewis-Clark Hotel is now found. The decision cited the precedent that lot owners prior to 1874 had valid claims to their properties. The survey was for the owners, not the owners for the survey. The legal point was moot by 1909. On July 6, 1977, the Fix and Moxley buildings were placed on the National Registry of Historic Places, but that designation did not save them. Despite repeated efforts to preserve the structures, they were demolished in August 1982.

The years from 1906 to 1909 seem to have been very quiet for Madgwick, who was spending his time building homes on Normal Hill. After five years of the most intense construction Lewiston has ever seen, he might well have been exhausted. However, he seemed to have one additional big project in him, and this time it would take him beyond the city limits.

East Lewiston, the area now just west of the Clearwater Paper Company plant, had developed far beyond expectations. Originally, it was known as Gurney and was full of small vegetable farms, fruit orchards and vineyards (*Historic Firsts* 52–54, 110–112). The rapid increase in population convinced the Lewiston school district that construction of a new campus there was warranted. The land was purchased in June 1910 from the Idaho Trust Company for $2,000 ($50,000). First called the East End School, it is shown

LOST LEWISTON, IDAHO

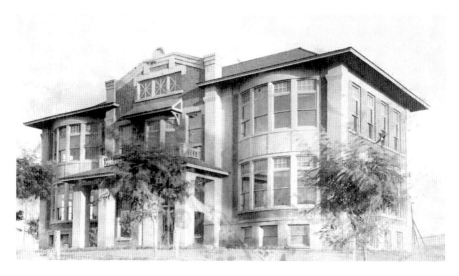

East End School (later Garfield), circa 1912. *Courtesy of the Jill Nock Archives.*

as Garfield Public School on Sanborn maps from May 1918. The building's style was very similar to the high school Madgwick had raised on Normal Hill in 1904, with large hallways, stairwells and the sash windows that were popular during the period. Funded with $12,000 ($300,000) and designed by architect James Nave, the structure is described as being in the Colonial Revival style (*Hidden History* 107–114). The building has since been converted into apartments and was added to the National Register of Historic Places in 1982.

In 1911, after more than thirty years of intense construction activity in Lewiston, Madgwick moved to Twin Falls, where he spent the rest of this life. In early July 1923, he reportedly fell and injured himself. The cause of the accident was a heart condition from which he had suffered for several years. He died in the local hospital on July 4 and was buried with Masonic honors in the city cemetery.

Aside from his skills as a contractor, one might be wondering: what do we know about the man? For one thing, he was a lifelong bachelor and was famously forgetful. "The most forgetful man Lewiston ever knew," one editor wrote in 1934. Madgwick would start walking from his lumberyard on Seventh Street and stop every one hundred feet or so, scratch his head and start back to his office. He had forgotten something. On one occasion, sometime around 1907, Madgwick needed to go to the old Idaho Brick Company factory that once operated near the current Clearwater Paper

Company plant. He went to a local livery stable and borrowed a horse from Jim Conley, for whom Harry had built a home on Normal Hill. Several hours later, Madgwick walked into the barn without his mount.

"Where's that horse?" asked Conley.

"By gosh," replied Madgwick, "I forgot him. I'll walk out and bring him in." And he did.

Men who worked for him loved to recount humorous stories about their former boss. Jim Smith was a foreman on many construction projects. Leon LeQuime ran the business office and was Madgwick's bookkeeper. They would tell people how difficult it was to fulfill contracts because Madgwick would sign a contract for a specific price and then insist on "throwing in extras."

"Harry, you're going to lose on that job if you make any more additions not called for," Smith would tell him. Conley would say that it was like throwing water on a duck's back. LeQuime would show Madgwick all of the figures and tell him the same thing—to no avail.

Harry Thurston Madgwick left nothing done halfway, and Lewiston's skyline was always the better for it.

San Francisco's *The Golden Era* printed its latest correspondence from its Idaho reporter Minnie Myrtle Miller on April 9, 1865.

What item can I give you from this inclement clime?—let me see. The Capital is removed from Lewiston to Idaho City, and Boise County is cut in two, and the prettiest half named 'Adah'…I smiled, the other day, to see our Governor's signature: 'Caleb Lyon, of Lyonsdale, Governor of Idaho.' Well, His Excellency is a poet, and poets are allowed long stretches of fancy, and long signatures too—if they like. (Hidden History 86–93)

2
POSTCARDS FROM OUR FATHERS

Old Town

We regret much of what we've built; we regret much of what we've torn down. But we've never regretted preserving anything.
—*Daniel Sack*

The clamor for bridges across the Snake and Clearwater Rivers grew louder on May 20, 1897, when a ferry sank just upstream of the city, on the Clearwater. The last group from a herd of five hundred cattle was being carried across to the stockyards when the sixty animals began pushing to one end. Reports indicate that the ferry had been overloaded. The ferryman tried to compensate, but the animals panicked and caused the lines to break. Thomas Aram, who could not swim, was thrown into the river. He tried to grab various floating items but failed. A $200 ($5,100) reward was announced for the recovery of his body, as he was carrying important documents.

Five months later, the Lewiston-Concord Bridge Company filed articles of incorporation to construct a span to cross the Snake River. Its efforts came to fruition on June 24, 1899, when the bridge—the first to span the Snake River between the communities—was opened for traffic, with tolls of $0.05 ($1.40) for foot traffic and $0.10 ($2.80) for a horse or wagon. While the fees might seem steep, they were vastly less than what ferries had been demanding since the 1860s.

As part of the festivities, the Ringling Brothers Circus, "America's Greatest Show," filled the Fifth Street Park with tents and attractions, highlighted by

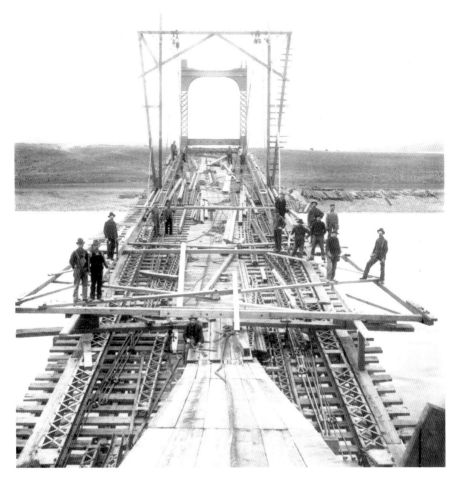

A construction scene at the first Snake River bridge, 1899.

John O'Brien's sixty-one-horse act and Lockhart's "Elephant Comedians" (*Historic Firsts* 103).

Concord, Washington, became Clarkston on January 1, 1900. The town had lobbied to be called Lewiston, Washington, but the United State Post Office balked, not wanting the confusion of two towns with the same name so close to one another. Ironically, all of the mail for Clarkston is now processed through the Lewiston post office.

Born in Germany in 1837, Joseph Alexander immigrated in the early 1850s and worked as a clerk in New York City to learn English before heading for

LOST LEWISTON, IDAHO

West Main Street, as viewed from the roof of the Moxley Building, circa 1910. *Courtesy of the Branting Archives.*

San Francisco in 1857. Alexander came for Idaho riches in 1860 and arrived in Lewiston in 1861. He drove a pack train of seventy mules between Lewiston and Helena, Montana, and served as an express messenger carrying gold from the Pierce City mines to Lewiston. The job was so hazardous that he was paid $100 ($2,300) for each trip. One of the city's earliest permanent merchants, he established a general mercantile business in Lewiston in 1870 and later purchased the Grostein and Binnard mercantile store on the corner of Main and Second Streets. A member of the Lewiston city council for fourteen years, he was heavily invested in real estate and was a vice-president and director of the Lewiston National Bank, as well as the Idaho Trust Company (*Historic Firsts* 89). When he died in December 1918, he left an estate in excess of $2,000,000 ($31.5 million).

Constructed before August 1862 by John Clark, one of Idaho's first district court judges, Clark Hall (also known as the Florence Saloon) once sat on the southeast corner of Third and Capital Streets and served in the role of the community center and theater, the first in the territory. The first and second territorial legislatures requisitioned the building as the meeting place for the lower house. In 1871, the hall was the site of a gala ball sponsored by several important local women that raised money to build Lewiston's first public school house. In later years, the building

ELEGIES AND BYGONE PLACES

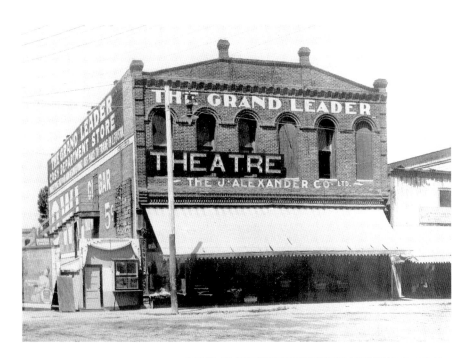

Above: Alexander General Store (formerly Grostein & Binnard), circa 1907.

Right: Joseph Alexander, 1890. *Courtesy of the City of Portland, Oregon Archives.*

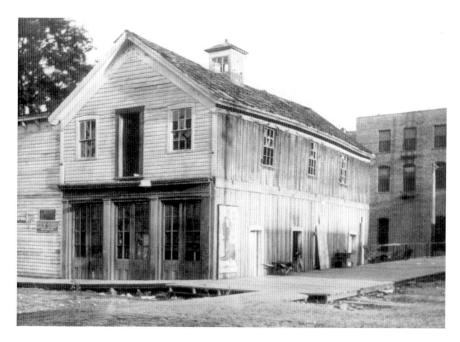

Clark Hall (Florence Saloon), circa 1905.

was home to the *Nez Perce News*, a Lewiston newspaper, from 1880 to 1888. The old structure was finally razed to make room for an expansion of the Bollinger Hotel (*Hidden History* 40).

The anchor business of the Weisgerber Building when it opened in January 1905 was the Owl Drug, which was founded in Lewiston by John T. Ray and Christian F. Osmers in 1896 and housed in two storefronts on Main Street for nearly a decade. Ray bought out Osmers' interests in 1903 and moved the pharmacy into the Weisgerber, where the company remained until 1987 (*Hidden History* 115). Lloyd Harris purchased the pharmacy, merging it with the Chastain-McNair Drug Company in 1917. Fire ravaged the pharmacy on April 1, 1919, and it again suffered heavy damage in August 1928, when a lighted match fell through the sidewalk and into the basement. A city councilman from 1905 to 1907 and a two-time mayor, Osmers operated the Idaho Drug Company until the early 1920s.

The Hotel Idaho once sat at the corner of Sixth and Main Streets. Originally built in 1906 by Angus Trimble for the McGilvery and Seeley Furniture and Carpet Company, it became a hotel in 1915, under the ownership of Herbert and Elaine Cole. The building's street level hosted a variety of businesses, including a cobbler shop, barbershops, a delicatessen,

ELEGIES AND BYGONE PLACES

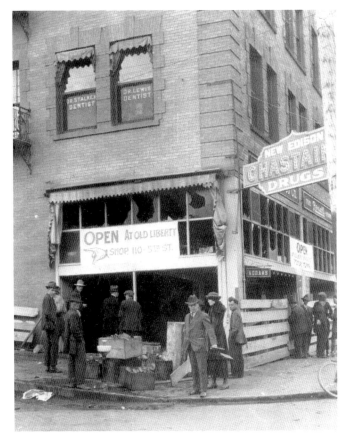

Right: The Chastain-McNair Drug Company, April 1, 1919.

Below: The Owl Drug (interior), circa 1940. *Courtesy of Brian Auer.*

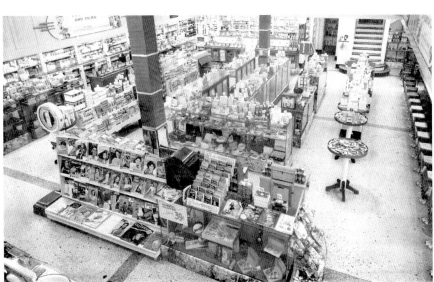

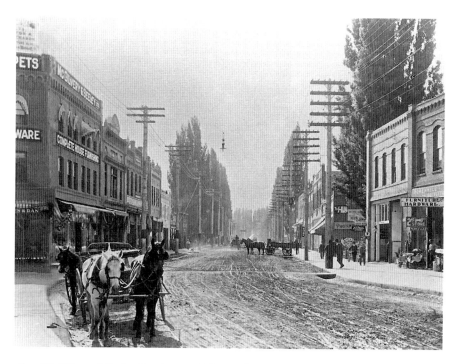

Above: McGilvery & Seeley Furniture and Carpet Store, Sixth and Main Streets, 1907. *Courtesy of Special Collections and Archives, University of Idaho Library.*

Below: Hotel Idaho, circa 1941. *Courtesy of Dana Brackenbury Bartlett.*

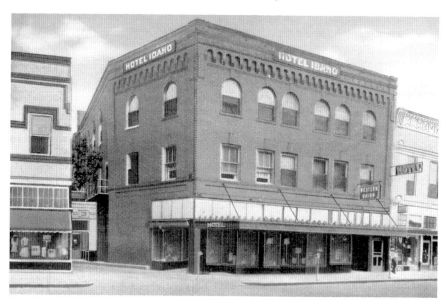

the telephone exchange, the Western Union office, a men's store and a pharmacy. The staircase to the Hotel Idaho's second floor also allowed access to the International Order of Odd Fellows meeting hall located on the second floor of the adjoining building. Fire gutted the hotel on January 9, 1976. After attempts to restore it failed, crews razed the structure and converted the lot to a city park.

Members of the Benevolent and Protective Order of Elks in Lewiston decided to organize an independent lodge in the city on June 24, 1903, to serve about fifty men living in Lewiston and Clarkston at the time. Two committees were formed to organize the lodge and find quarters for the group. The lodge was chartered in 1904 and began meeting at the old Masonic Lodge on First Street (*Historic Firsts* 35). After the building burned in September 1904, the lodge moved to the Mounce block at 708 Main Street, which was also the site of Lewiston's post office until 1912. The cornerstone of a new Elks Temple was laid on November 25, 1924, across the street at the corner of Eighth and Main Streets. This building was destroyed by fire on September 24, 1969, with losses estimated at $1 million ($5.8 million), the greatest loss in Lewiston to date. "When our men first entered the building, they found a rolling fire...It was really going," said Lewiston fire chief

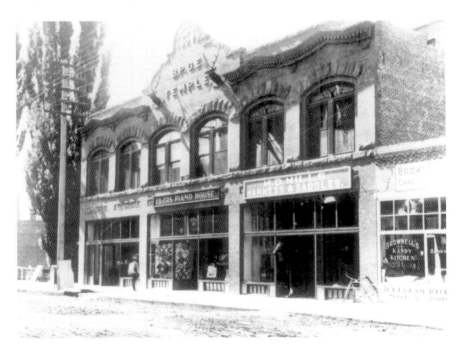

Mounce Block, 708 Main Street, 1907.

Elks Lodge, Eighth and Main Streets, circa 1952.

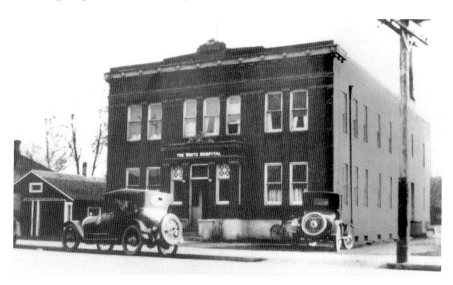

White Hospital, circa 1925.

Leonard Ellis. The lodge lost nearly all of its early records and photographs. The board of trustees met the next day to announce that lodge business would go on as usual and that the Lewiston Country Club had been leased for meetings.

ELEGIES AND BYGONE PLACES

On June 20, 1916, Dr. Edgar Lee White, a northwest native and 1909 graduate of the Rush Medical School in Chicago, opened his hospital at 1502 Main Street, in what was a financially risky venture for a young doctor. Dr. White came to Lewiston in December 1910 to work with Dr. C.P. Phillips, who died the next year. White took over the practice. During the Spanish influenza, White's wife, Catherine, a trained nurse, opened an emergency hospital in the small town of Nezperce, the first on the Camas Prairie. Dr. White also operated a nursing school at the hospital. The facility closed in 1946 and was later used as a nursing home and apartment building.

For other images from this area of Lewiston, see: *Historic Firsts* 19, 23, 30–31, 35, 45, 63, 73, 79, 86, 100, 111 and 114. *Hidden History* 35, 40, 72, 78, 102, 104, 106–107, 115, 120, 127 and 129.

The Lewiston City Council acted dramatically on September 17, 1923, in the wake of what would today be called "a hate crime." On Friday, September 14, shortly before midnight, Georgia Cross, "a colored woman" living at Fifth and C Streets, reported to police that three "hooded men" called at her home. She fled. A friend, also African American, spoke to the group, who claimed they just wanted to see that "Georgia Cross cut out her right stuff." What that "stuff" was has never been determined.

At its regular meeting, the council gave Police Chief Eugene Gasser his orders:

> *You will assure yourself that all members of your force carry arms at all times and are proficient in their use. In proper cases, you are instructed to shoot and shoot to kill...Justice cannot be administered by a mob made up of men who do their deeds under the cover of darkness and hide their identity behind masks.*

The council's message fell on a few deaf ears. On September 23, 1924, the Knights of the Ku Klux Klan held a meeting at the Temple Theater. "Don't judge this great law-abiding Order by hearsay" read the invitation mailed to men throughout the community, an invitation that was required for entrance and was to be kept "absolutely confidential."

3
PIETY AMIDST THE DUSTY PROMISE

The church is the great lost and found department.
—Robert Short

When people clamor for a new religion, what they really want is a religion that isn't too religious.
—Robert Quillen

If you were a Lewiston resident in the city's early days and were a churchgoer—yes, there were several among the local gamblers, saloon owners, opportunists, rowdies, prostitutes and ne'er-do-wells—your Sunday worship services were infrequent at best. Circuit-riding ministers toiled to reach Lewiston by way of poorly maintained roads or, depending on their route, a river steamer. Peter Josef Ley, a German immigrant who owned a bakery on Main Street, wrote to his father and brother on January 15, 1865:

> *You cannot imagine with what different characters of people you have to deal with here. It is not as difficult to make money here as it is to keep it, since there are many people here who have already been very rich and had enough gold; however they lost all their money due to carelessness or bad people (of which there are many here). I pray to God that he may protect me from misfortune.*

The first territorial legislature made a puritanical and short-lived attempt to bring religion to the frontier. On January 23, 1864, legislators enacted the

so-called Lord's Day Act, Idaho's first blue law. In part, the act read that "no person shall keep open any play house, or theater, race ground, cock pit or play any game of chance or gain or engage in any noisy amusement on the first day of the week." Fines ranged from $30 to $250 ($400 to $3,500). The legislation was unenforceable. William McConnell, who would later serve as Idaho's third state governor, recalled that many government offices went vacant as a result of the statute, as few men would affirm that they would abide by it. Idaho towns had saloons, brothels, blacksmiths and bakeries. But a church? Civilization was still a few years away. As with most of the bills passed by the first legislature, the law was repealed. Towns would need to chart their own paths.

Abigail Scott Duniway's observations in the December 11, 1879 issue of the *New Northwest* are a telling commentary:

> *The stranger is a little surprised that a town as old as Lewiston is so destitute of churches and other public buildings. Nor is his wonder lessened when he sees the people so orderly, intelligent and hospitable as to put to shame full many a town we wot [know] of, where the good citizens are pestered to death for money to pay needy parsons and build rival churches…We opine that there is more religious tolerance and general reverence here for the real Gospel now than there will be when every rival sect has sent a church spire heavenward, and further depleted the people's finances by buying bells and organs for the exclusive use of the self-righteous few who control them.*

Early Lewiston congregations were very small, most numbering fewer than ten individuals. Until 1879, when the local Universalist congregation built a church on the corner of Seventh and Main Streets, Lewiston is said to have had only one edifice dedicated for services. Father Joseph Cataldo had built that single house of worship in 1868. However, this overshadows the real genesis of Lewiston's religious heritage. That is where our story begins. In the following accounts, which include short biographies of prominent members of the early congregations, the dates given represent when the faiths established their local identity.

Jewish — 1862

Lewiston's once thriving Jewish community began with the arrival of Robert Grostein in 1862 to a rough-and-tumble community. He later recollected

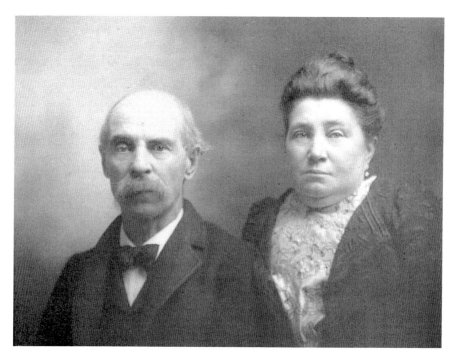

Above: Robert and Rosa Grostein, circa 1905.

Left: Abraham Binnard, circa 1896. *Courtesy of Birk Binnard.*

that the very night of his arrival a man was murdered on Main Street. Until 1865, Robert and Rosa Grostein *were* the Lewiston Jewish community. The congregation grew to three on July 7, 1865, with the birth of the Grostein's daughter Leah, who would be followed by five brothers and sisters.

The Jewish population swelled on May 12, 1867, with the arrival of Robert's brother-in-law Abraham Binnard, along with his wife, Rachel; two daughters; and Rachel's brother Lewis. Robert was at the wharf to meet him when the steamer arrived. The families relate that their first words were "Hello, Bob" and "Hello, Abe." The Binnards' grandson later reported that only eleven white families were living in the town at the time. Rachel Binnard took one look at the primitive settlement and promptly wanted to return to Buffalo, New York. Rachel bore Abraham five more children in Lewiston. As the daughters and nieces grew to adulthood, new names were added to Lewiston Jewish assembly: Kuhn, Goldstone, Kaminsky, Greenburg and Cohen. Joseph Alexander arrived in 1870.

Over six feet tall, Abraham Binnard was an imposing figure among Lewiston's residents and took an active role in the community. He was elected to the school board and is said to have been, from time to time, a member of local vigilante groups. A retrospective appearing in the November 3, 1935 *Lewiston Morning Tribune* related that he once proposed a city ordinance forbidding cowboys to ride on the sidewalks because the wooden walk in front of his home had been damaged by horses. When he was not managing the many holdings of the company that he and his brother-in-law owned, Binnard loved to go fishing on the Snake and Clearwater Rivers. Rachel had to track him down or send boys to throw rocks in the river in order to encourage him to come home for dinner.

There is no evidence that Lewiston ever had a synagogue, which is not required for worship in the Jewish faith. When one considers that travel to the West would have made keeping Kosher nearly impossible, the families were likely Reform Jews. The 1870 federal census shows the families living next door to one other, and we can easily surmise that prayers services, seders, brit milahs (circumcisions), funerals, bar mitzvahs and bat mitzvahs were observed or conducted in their homes (*Historic Firsts* 23).

Although the families would have enjoyed the services of a rabbi, the closest active synagogue was located in Portland, Oregon. River travel from the coast to Lewiston was well established, but in the 1880s, the trip took three days. Still, Leah Grostein's marriage to Aaron Kuhn in Lewiston on May 8, 1884, would have been solemnized by a rabbi (*Historic Firsts* 57–58). The establishment of the Jewish section in Normal Hill

Cemetery in 1895 would have been accompanied by religious services, most likely led by a rabbi from *Temple Emanu-El* in Spokane, Washington, founded in 1891.

Episcopal — 1864

On Christmas Day 1864, a small group of local Episcopalians gathered together in a log building once located on D Street, where the Lewiston City Library now stands (*Historic Firsts* 55–56). The church was new to Idaho, with a congregation in Boise only lately created by the Reverend J. Michael Fackler, the first Episcopal minister in the Pacific Northwest and the founder of several churches, including Saint Paul's in Walla Walla, Washington. The Reverend Lemuel Wells, Fackler's successor, began making visits to Lewiston in 1874. Lewiston's congregation owes much to the work of Bishop Benjamin W. Morris and Reverend Dr. Reuben Nevius, but the town remained on the circuit riding schedule until July 1881, when John Douglas McConkey arrived after serving as rector of Saint Paul's.

The Lewiston congregation had no building of its own until 1891, when a new church and rectory opened on Eleventh Street, near its intersection with Main Street. That building, which is the oldest continually used church in Lewiston and now sits at the corner of Eighth Street and Eighth Avenue on Normal Hill, is of particular interest architecturally. It contains several stained-glass windows, which were endowed by some of Lewiston's wealthiest families. The altar window was created in the memory of Evangeline Vollmer (*Hidden History*, chapter 3). Called the "nativity window," it survived being shipped around Cape Horn and up the Columbia and Snake Rivers to Lewiston to be installed as part of the finishing stages of the church's construction.

Another of the congregation's important leaders was Reverend D.J. Watson Somerville, who also served as a faculty member at Lewiston High School and Lewiston State Normal School. The church's third rector, Somerville came to Lewiston in 1904 and organized the dismantling of the church edifice to move it to Normal Hill in 1920. It was Somerville who married Walt Disney and Lillian Bounds on July 13, 1925, at her brother's home on Normal Hill's Third Street. He died after being hit by a truck near the old Temple Theater on Main Street on December 28,

1929. Dr. Somerville had recently opened a hospital and retirement home in east Orchards.

In addition to John and Sarah Vollmer, several important Lewiston families were members of the early congregation, including William and Mary Jane Kettenbach, Edward and Viola McConville and Mark Means.

Born in Silcott, Washington, Mary Jane White was the daughter of Daniel and Elizabeth White. Her father ran a ferry for John Silcott and operated a cattle ranch at the time. The town of Silcott was once located at the base of Alpowa Grade, near the present-day Banner Ranch and is now inundated. By 1885, the White family had moved to Lewiston and lived on the stretch of old E Street, now known as Snake River Avenue. Her father later served a term as mayor, and she graduated with the Lewiston High School with the class of 1895. She married William Kettenbach Jr. that year (*Hidden History* 101–102). On learning of her death in 1939, Dan W. Greenburg, a longtime reporter for the *Lewiston Teller* and *Morning Tribune*, described her as:

> *A wonderful girl in her youth and womanhood. In school where I attended, she was the life of the school. Always an outdoor girl and fond of outdoor life, she was a leader among both girls and boys. There was nothing snobbish about her—just a healthy girl full of life and loved by everyone. The strength of her wholesome influence in the community is a severe loss, because she always had the characteristic qualities of leadership.*

Viola Arant came to Lewiston in 1877. She recollected that the stagecoach driver told her that "Indians attacked this stage near Boise yesterday." She commented that he was probably just trying to scare her. Viola had studied to be a teacher at Elmira College in southern Illinois and came west looking for a job. Her parents were living in Lewiston. Here she met Edward McConville, and they married in 1878. Viola applied for a teaching job, and a school board member asked her, "What would you do to an obstinate pupil?" She replied, "I'd give him a licking," and was hired, teaching grades one through four at the first public schoolhouse on Main Street (*Historic Firsts* 101–102).

When Marcus Means rode into town in 1881, he was broke and not yet twenty years old. His business acumen would earn him a place among the city's most famous residents. An orphan, he had headed west for "good soil." His financial career began as a banking assistant for John P. Vollmer. After the panic of 1893, Means opened a store in Genesee, made a profit and branched out to Lewiston. In 1905, he financed a building at Fourth and D

Streets that still bears his name. Incorporated in 1923, the Mark Means Company became a major supplier of grass seed, beans and peas in the inland northwest. The first warehouse was built at Fifth and B Streets, with a sorting plant installed later at Second and B Streets. In 1909, he pioneered the use of trolleys on the city's Main Street and was a major proponent of the streetcar line that linked Lewiston with Clarkston from 1915 to 1928. He ran for Idaho governor in 1926 and was a delegate to the Republican National Convention in 1928, 1932 and 1944. In his later years, Means was a vocal proponent for the formation of a county historical society.

Taoist — circa 1865

The Chinese were not welcomed to the Idaho Territory with open arms. Fearful of the effects the Chinese would have on the lucrative mining industry, the territorial legislature prohibited them from working in the gold fields until 1864 and only then after forcing them to purchase a license, a stipulation not foisted on white settlers. Still, the Chinese came. The 1870 federal census shows that 4,274 Chinese were working in the territory, nearly 29 percent of the population and the highest concentration of Chinese anywhere in the United States, with Lewiston's percentage being even higher. Lewiston pioneer James Conley related that when he arrived with his widowed mother in 1867, there were more Chinese among the town's three hundred inhabitants than non-Chinese.

The majority of the Chinese who found their way to Lewiston were natives of the Guangdong province, an area in southern China that most Americans would recognize as Canton. These immigrants practiced Taoism, which combines elements of Buddhism and Confucianism with local folk beliefs. Most westerners are familiar with the yin and yang symbol that is used in Taoism to express how contradictory forces in nature complement each other. Taoist beliefs stress the nurturing of a relationship with nature and the universe, along with a veneration of ancestors.

Locals called the Chinese temple a "joss house," the word joss being a corruption of *deus*, Portuguese for god. The Portuguese had been the first to open trade with China in 1513 in Guangzhou, the largest city in Guangdong province. After the first Chinese arrived in Lewiston, their religious services remained dependent on family altars. The first mention of a temple appears in the *Idaho Signal* on October 5, 1872: "We have been told that the Chinese

of this city have bought a block of land near the steamboat landing, upon which they intend to construct a josh [*sic*] house for worship." The resulting building was destroyed by fire in March 1875, with a replacement erected a few months later.

As repeated flooding made a secure shoreline along the Clearwater River impractical, A Street from the confluence to Fifth Street was vacated before 1880, and city blocks one through five were declared "vacant." The northern edge of the city moved a block south, with the steamboat landing reconstructed at B (now Beachey) and First Streets. By the early 1880s, the Chinese had clustered along First Street between C (now Capital) and D Streets, near the first county courthouse, where the Lewis-Clark Hotel now stands.

From 1888 to 1896, this neighborhood was labeled on Lewiston's first Sanborn fire insurance maps as "China Town," a remnant of the structures destroyed on November 19, 1883, when volunteer firemen hesitated to fight a major blaze. Although no temple appears in records, retrospectives written in the early 1960s in collaboration with the remaining Chinese community relate that "a Chinese temple" burned down in the conflagration that destroyed more than a dozen structures. The "temple" might well have been a confused reference to the family altar of Tu Guong, one of the most prominent members of the Chinese community until his death in 1887. Within a month of the fire, the city passed Ordinance 67, which targeted "China Town" and forbade the construction of stick-and-frame buildings there.

Beginning in 1888, the local Chinese community was soliciting funds to construct a new temple. By 1890, they had purchased new property on C Street, on the site where the *Lewiston Tribune* now has its building. More than five hundred donors raised $925 ($25,000) for the temple's construction. It is safe to say that that nearly every Chinese in the Lewiston area contributed, as there were only about two thousand Chinese in Idaho in 1890. Many scholars assert that the new temple was a reaction to the massacre of more than thirty Chinese miners at Deep Creek on the Snake River, upstream from Lewiston in May 1887. Several of the miners' bodies floated all the way to Lewiston and were buried in the original Chinese cemetery on Prospect Avenue.

The Taoist temple in Lewiston has always been known as the Beuk Aie Miao (pronounced "buck eye meow," the word *miao* meaning "temple" in Chinese). Beuk Aie is a Chinese god of water and is often associated with rivers. This would have been an obvious choice for the elders as they surveyed the valley and its confluence of two rivers.

One of the best-known members of the Beuk Aie Temple was Ted Loy (Eng Moon Loy). Born in Taishan, China, in 1879, he immigrated to Seattle

Chinese temple (colloquially called a "joss house"), C Street, circa 1960.

in 1891 and found employment aboard steamships making the run from Celilo Falls, Oregon, to Lewiston, where financier John P. Vollmer took notice of him and hired Loy as a household servant in his new home on Normal Hill. Loy later became associated with the Bollinger Hotel, retiring in 1968 and dying in 1981, at the age of 101.

The *Tribune* traded property with the Chinese community in 1959 in order to expand the printing plant, and the joss house moved to a concrete block building across the street. The days of a Taoist place of worship in Lewiston ended in 1991. The old structure was so unsound that the remains of the temple were removed and are now displayed at the Lewis-Clark State College's Center for Arts and History. The building was sold in 2014 and razed.

Roman Catholic—1867

Lewiston's Catholic church was the product of the work of Father Joseph Cataldo, but as with other congregations, he was not a resident minister (*Historic Firsts* 60–61). His work took him to several venues, including the Nez Perce reservation. The Protestant ministers on the reservation protested his

Right: Christ Weisberger, circa 1906.

Below: Saint Stanislaus Church (right) and St. Aloysius School (left), circa 1890.

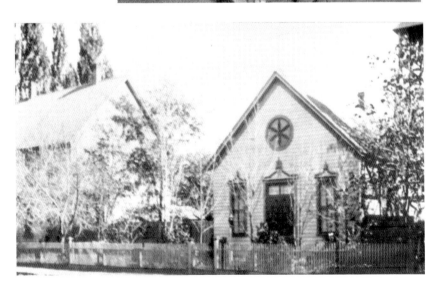

appearance there, but Cataldo discovered that many Nez Perce were already familiar with the Roman Catholic faith. If he could not go to the Nez Perce, they would come to him. On May 14, 1872, Cataldo baptized several Nez Perce at the old Lewiston church just outside of town. A door had opened, and in September 1874, a mission was dedicated at Slickpoo. In 1883, Cataldo was assigned to Spokane, and Father Alexander Diomedi accepted the Lewiston assignment and became the parish's first resident priest.

Diomedi realized that Cataldo's little frame church was not up to the task of serving the city's growing number of communicants. In 1886, he spearheaded the construction of a new Saint Stanislaus Church on Fifth Street, between Main and C Streets. Diomedi was described in 1894 as "a man of grit and uncommon energy, and to use a western expression, a genuine 'rustler.'"

While Jesuits served Lewiston from the beginning of the parish, four different orders of nuns have worked in Lewiston. The Sisters of Saint Francis arrived with the establishment of the Saint Aloysius Academy, where they worked as teachers. The Sisters of the Sacred Heart came after them, but left with the closure of the school. The Sisters of Visitation found their way to Lewiston in late 1895 but had their own plans to open a girls' preparatory school on Normal Hill (*Hidden History* 21). The school was prospering when the Sisters of Saint Joseph came to Lewiston in 1902 with the expressed purpose of staffing and operating a proper hospital for the community.

The work of Father Hubert Post deserves mention. His immediate predecessor, Father Michael Meyer, petitioned the Sisters of Saint Joseph to come to Lewiston in 1897, but Post carried the project to completion when Saint Joseph's Hospital opened its doors to patients in 1903 (*Hidden History* 102–104). It was he who organized the Holy Family Parish (1901) in Clarkston, oversaw the purchase of Visitation Academy and supervised the construction and opening of a new and much larger Saint Stanislaus Church (1905) that still stands on Fifth Avenue on Normal Hill. In early 1904, he proposed the establishment of the all-male Koska College, which was envisioned to have law and medical departments and to be "as large an institution as any in the country," rivaling Gonzaga in Spokane, Washington. Once fully established, the college would become Lewiston University. Ten acres were set aside for the project, which, as any Lewiston resident knows, never came to fruition.

The missions at Our Lady of Lourdes on East Main Street and the Sacred Heart, near the current Clearwater Paper Company mill, date from 1916 and 1919 respectively. Sacred Heart closed in 1939, with

Lourdes moving to Twenty-first Street in 1947. Lourdes had its own school from 1957 to 1971.

One of the earliest communicants in the Lewiston parish was Christ Weisgerber (*Historic Firsts* 30–32). His family home stood at First and D Streets until after World War II. He served on the Lewiston city council for nineteen years and was mayor for two (1898–1899). The Weisgerbers took up a number of pews in the church. His first wife, Isabel, died in 1880. He remarried in July 1882 and sired nine more children. Five of his children survived him upon his death in November 1914.

Joining the Weisgerbers as early members of the church was the family of Dr. Henry and Marion Stainton (*Historic Firsts* 15–17).

Presbyterian — 1873

Presbyterianism came to Idaho with Henry Spalding in 1836 and gained the first Christian foothold in the region (*Historic Firsts* 62–64). Lewiston's first Presbyterian minister, Thomas M. Boyd visited the city in June 1879 and found only Cataldo's "chapel" standing as a place of worship. When he returned in March 1880, he immediately began planning the construction of a church "dedicated to the worship of Jehovah," which would arise next to the schoolhouse on Main Street. After he left in 1885, L.W. Siebel took up the mantle and was succeeded in turn by J.E. Sherman and Ezra P. Giboney as the century closed. Giboney presided at the funeral for Arthur and Paul Talkington (*Hidden History* 18–27).

In June 1908, the congregation received a $12,000 ($310,000) bequest from the estate of Sarah C. Thompson. The church trustees agreed to set aside the money to purchase a new site and construct a new church for the congregation, which finally occurred in 1922. Mrs. Thompson was the widow of Samuel C. Thompson, a prominent resident described in 1872 as one "of the chief wealth holders of the county" and owner of more than 160 acres just east of the old city limits, at what is now Fourteenth Street.

Among the early congregants was Perrin Whitman. Nephew of Presbyterian missionaries Marcus and Narcissa Whitman, he was in Dalles, Oregon, at the time of the November 29, 1847 Waiilatpu massacre near Walla Walla, Washington. In 1863, he was appointed subagent and official interpreter at the Nez Perce Indian agency in Lapwai, taking part in negotiating treaties and

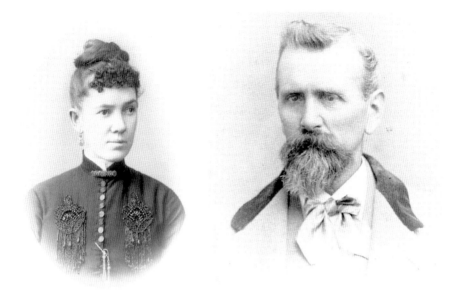

Harriet and Seraphin Wildenthaler, circa 1885. *Courtesy of Doug and Lorna Marsh.*

other history-making events of Idaho Territory. He moved to Lewiston with his family in 1883. Perrin was the great-great-grandfather of a very famous American entertainer, but you can read of that later.

Born in 1827, Seraphin Wildenthaler was the son of a German immigrant who settled in Sandusky, Ohio, in 1852. He came west in 1854 to prospect for gold in California for eight years. While en route to Idaho, hostile Indians attempted to stampede the horses of his party. One morning they found the ground filled with arrows that had been shot at them in the night. After arriving in Lewiston in 1862, Wildenthaler began traveling again. He witnessed the driving of the golden spike at Promontory Point, Utah, in May 1869. He had been operating a bakery that moved along the Union Pacific railway line as it extended westward. He returned to Lewiston to stay in 1870 and established himself in business, particularly as a baker, as a partner in the California Bakery, and served on the city council from 1887 to 1891. He married Harriet Palmer, twenty-seven years his junior, in 1877.

Mrs. Wildenthaler came to Lewiston in 1875 and was very active with the newly formed Presbyterian congregation and the original chapter of Eastern Star (Gem) and its successor (Laurel). When the Tsceminicum Club took over the sponsorship of the Carnegie Library project, Mrs. Wildenthaler assumed a leading role and was, by many estimates, largely responsible for seeing the

project to completion (*Historic Firsts* 116–117). She was president of the club in 1906–1907. In the early 1910s, she helped organize and was president of the Associated Charities of Lewiston, a group that banded together, much like today's United Way, to help the needy. Her work continued until the Red Cross became established in the city.

Methodist—1876

Note: The official name of the church was Methodist-Episcopal, a designation that would last until 1939. In order to alleviate any confusion with Lewiston's Episcopal congregation, I will use the word Methodist.

Sometime in the late 1860s, an unnamed traveling Methodist minister spent several weeks in the Lewiston area and reported that the new community would be a good candidate for a church. Years passed without action. In June 1876, G.W. Shaffer delivered the first sermon at the town's first public schoolhouse. E.C. Rigby replaced him in 1877 and organized the first Methodist society on February 22, 1879. Enough progress was made that Reverend J.W. Rigby was able to leave the circuit work on February 10, 1881, and begin service as the congregation's first resident pastor. The group averaged ten adults attending services. The members held frequent holiday dinners open to the public in an effort to raise funds for a new building. Those efforts finally produced a church, which opened on September 17, 1885, on the corner of Eleventh and Main Streets.

By 1905, the congregation had been served by sixteen different pastors when William Tell Euster arrived. Euster never met a congregation that did not need a new church. The twenty-year-old building on Eleventh Street was not grand enough for him. So he convinced his parishioners to sell the church and take on a project to erect a new $40,000 ($1 million) stone structure on Normal Hill. He wanted to place it in the Fifth Street Park (now Pioneer Park), but the city would not agree.

A lot on the corner of Eighth Street and Sixth Avenue was purchased, but Euster had stars in his eyes. His *modus operandi* was to build an audience room as large as the congregation could afford. A color postcard from circa 1906 shows his vision: an edifice half a city block long on both streets, anchored by a spire that would have been more than one hundred feet to its pinnacle, had it been built. The architect, Henry Nelson Black, also designed Methodist

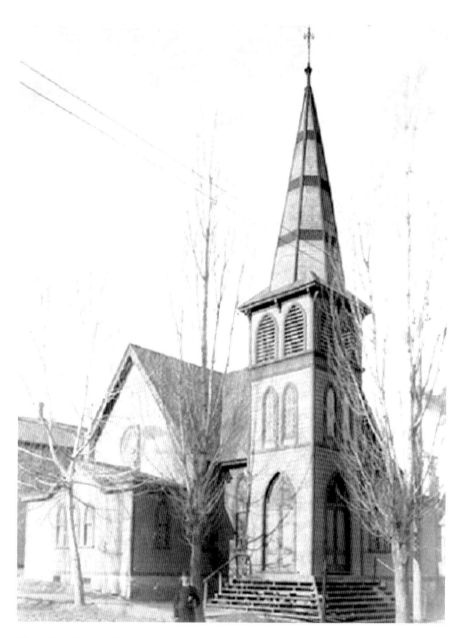

Methodist Church, Eleventh and Main Streets, 1892. The man seen at the bottom of the image is Rev. Grant Haven. *Courtesy of the* Lewiston Tribune.

ELEGIES AND BYGONE PLACES

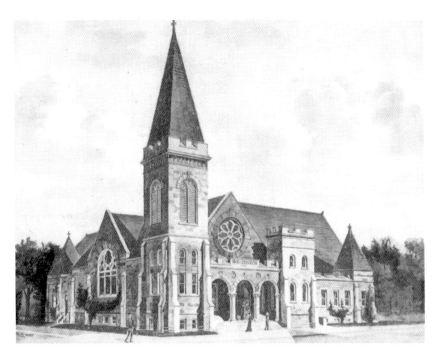

The Methodist Church proposed for construction on Normal Hill, 1906. *Courtesy of the Branting Archives.*

churches in Great Falls and Anaconda, Montana; Moscow, Idaho; and Portland, Oregon—all at the time when Euster was the minister. There is an old expression for this arrangement: "dog and pony show."

When Euster left for a new assignment in Pendleton, Oregon, in 1908, the Lewiston congregation was deeply divided and carried a massive debt. Plans had been scaled back dramatically, but the financial damage had been done. Dubray Brothers, the contractors for the project, placed a lien on the building, and the structure was not completed until 1909, after the Methodist national headquarters came to the aid of the congregation with a loan of $5,000 ($130,000 today). Euster would continue his campaign of building, even publishing a book entitled *The Philosophy of Church Building*. The congregation took years to recover. Today, the building is the Anne Bollinger Arts Center and houses the Lewiston Civic Theater.

Some of Lewiston's most prominent families were members of the early Methodist congregation. Chester Coburn settled in Lewiston by 1862 and established a livery stable and implement store that served as Idaho's first statehouse (*Historic Firsts* 44–45). He handled horses for Hill Beachey,

Chester P. Coburn, circa 1899. *Courtesy of the Branting Archives.*

George Manning, 1905. *Courtesy of the Swinehart Archives.*

proprietor of the Luna House Hotel, and was with Beachey in October 1863 when he sensed odd behavior in a man who came into the hotel and bought several tickets for the morning stage to Walla Walla. Coburn helped Beachey uncover evidence of the murders of packer Lloyd Magruder and four other men. And who was that man who was acting strangely? He was one of the killers, who would be hanged in March 1864.

Coburn was the president of the school board that constructed the first public school in 1872 at Tenth and Main Streets, having procured the property from a group of men who had won the parcel in a card game. He helped complete Idaho's first census in July 1870. His territory took in the region from Canada in the north to beyond Elk City to the south and east. Coburn was an early leader of the Masonic Lodge and served several terms as a justice of the peace (*Historic Firsts* 34–36).

James W. Reid volunteered as a drummer in the Confederate army with the Second North Carolina but was placed in the reserves for being underage. Admitted to the bar in 1873, he was treasurer of Rockingham County from 1874 to 1884. Reid served in the Forty-eighth

and Forty-ninth Congresses as a representative from North Carolina. After moving to Lewiston in 1887 to practice law, Reid was a member of the state constitutional convention in 1889, serving as vice-president. His lobbying led to the establishment of Lewiston State Normal School in 1893, and until his death in 1903, he was president of the board of trustees. In 1896 and 1900, Reid was a delegate to the Democratic National Conventions. Today's Reid Centennial Hall, opened in 1896, is the original building for the college.

After enlisting in California, George A. Manning accepted a commission to command Company M, California Battalion, Second Massachusetts Cavalry. He was captured at Dranesville, Virginia, on February 22, 1864, and would remain a prisoner of war until the war's end. After arriving in Lewiston in 1870, he served as a sergeant in Company A, Second Regiment, Idaho Volunteers, during the Nez Perce War (1877). Manning was the first commander of Lewiston Grand Army of the Republic post (1882). He was a delegate to the Tenth Territorial Legislature and was also a deputy United States Marshall. In 1893, President Benjamin Harrison appointed Manning as the Idaho commissioner for the Chicago World's Fair.

Universalist—1877

Melanie Le Francois (*Historic Firsts* 18–19; 65–66) owned a tract of land on the northeast corner of what is now Seventh and Main Streets and was ready to sell it. The First Universalist Church wanted property where it could build a church. The first minister, Reverend E.A. McAllister, struck a deal in August 1879, and the small congregation began construction later that year. After Reverend Lee Fairchild left for greener pastures in 1888, the building passed into the hands of several groups, including the Grand Army of the Republic and the local Baptist congregation. The tiny congregation continued to function in private homes but finally faded into the town's past (*Hidden History* 95–96). However, Fairchild's exploits deserve a few more comments.

On one occasion, he was sent to South Carolina on a stump speaking tour for the Republican Party, in an era when they were unwelcome there. During one of his speeches, some young rowdies in the audience thought they would heckle him and started shouting "Rats! Rats!" Fairchild raised his hand to silence the crowd and turned around. "Waiter, waiter," he called out, "take these Chinese orders." The audience roared with approval. The

notice of Fairchild's death in the March 20, 1910 *San Francisco Call* had an obvious Lewiston connection. After commenting that he had trained for the ministry, the article stated that "domestic difficulties followed his marriage and he left the church."

Among the trustees of the Universalist congregation were Madison A. Kelly (*Historic Firsts* 38), Jonathan M. Howe and Edmund Pearcy, who came west in 1853 to settle in the San Joaquin Valley of California. Born in 1831, Pearcy was a member of the John Mullan expedition that explored north Idaho and the Bitterroot Mountain region in 1850. He came to Lewiston in 1861, operating a ferry for thirty-three years across the Snake River from the city to what would become Clarkston, as well as owning one of the first sawmills in the region. He and his wife, Jennie, were married in Lewiston on December 6, 1881. Pearcy was a charter member and officer of the Nez Perce

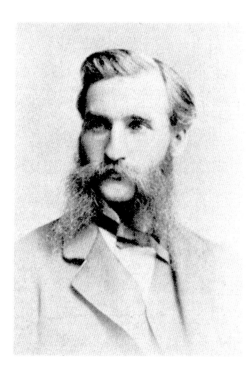

Top: Lee Fairchild, circa 1890. *Courtesy of the Branting Archives.*

Left: Jonathan Morris Howe, 1890. *Courtesy of the City of Portland, Oregon Archives.*

County Pioneer Association (1900). Upon his death in June 1902, he was said to be, along with John Silcott, one of the oldest surviving residents of the tent city that became Lewiston in May 1861.

Lewiston shut down on May 29, 1894, from 1:00 p.m. to 4:00 p.m. out of respect for one of its civic leaders—Jonathan Morris Howe. After having served as mayor (1887–88), Howe was elected as city clerk (1889–92) and city attorney (1890–92). He was a member of the city council in 1889 and was a delegate to the Idaho Constitutional Convention in 1889. He was elected to the Idaho State Senate in November 1892. Howe was a member of the first board of trustees for Lewiston State Normal School and was the president of both the Clearwater Horticultural and the North Idaho Horticultural Societies. In 1874, Howe applied to teach at the public school. At that time, teachers were hired by the city council, which acted as the school board. His wife, Ellen, served many terms as the Universalist Church Centenary Woman's Association for Idaho and Washington.

SEVENTH-DAY ADVENTIST—1885

The first church services were organized by Mrs. Emeline Akins Phillips, who was a teacher at the public school on Main Street (*Historic Firsts* 86). Early meetings continued to be held in the homes of the members of the small congregation until the East End Mission was constructed at Twenty-second and Main Streets (see Baptist section).

In 1917, the congregation, then under the leadership of James Cathcart Cole, constructed its own building at 215 Eighteenth Street. The February 27, 1904 *Corvallis (Oregon) Times* described Cole as "a thorough Bible student,

James Cathcart Cole, circa 1900. *Courtesy of Judith Cole.*

and while he delivers sermons upon occasion, he believes that, in a general way, more can be accomplished by teaching as in the Bible class" By 1920, the congregation had grown to seventy-five members and was the largest in north Idaho.

Lewiston Tent and Awning purchased the building after a new church was constructed and dedicated on Nineteenth Street in 1955. Originally located at 2202 Eighth Avenue, Beacon School dates from the fall of 1919, with Mrs. William B. (Effa) Ammundsen as its first teacher.

Salvation Army — 1895

Ensign Shea and Lieutenant Morris, together with a musical group called the Crusaders, traveled from Spokane in hopes of establishing a new Salvation Army post in Lewiston. In an article for the *War Cry*, the Army's magazine, the two recounted the excitement of their stagecoach trip down the old Uniontown Grade and their first visit to town. The Crusaders had arrived the day before and hired a hall, using it as their dormitory for the night. Shea and Morris shared a crowded coach with the Crusaders' musical instruments. In their account to church leaders in Spokane, they reported:

> *The boys sold War Cries, and the newsmen gave us a big sendoff, so we went to work. We visited all the homes and business houses, including the saloons, fourteen of them. At our open-air meeting in front of the Silver Dollar Saloon, one man came out and joined us. He also stayed with us during our Saturday march down the street and sang with us. We were able to add four more to our collection of saved ones, collected eleven dollars, and had a record drown on Sunday night. The proprietor of the saloon said he would pay the rent on the hall if we would return the next month.*

Captain Lydia Burton and Lieutenant Jesse Long opened a church on Main Street by February 1896 in the basement of an old wooden building that once stood just west of the present site of the YWCA. By December 1900, the church had found a storefront in the 200 block of D Street near the Hong Shing laundry (*Hidden History* 107).

The congregation moved frequently from one rented space to another until 1920, when it acquired its first permanent headquarters in a building at

0212 Fourth Street, facing the old Lewiston *Morning Tribune* offices. By April 1940, the congregation had moved temporarily to 221 Main Street before obtaining an old motorcycle repair shop later that year at 227 Ninth Street, at the base of the grade to Normal Hill.

In early March 1949, the congregation moved into the old Prayer League Tabernacle building (now gone) at 1102 Idaho Street. The church acquired the former Clearwater Power Company building on east G Street in 1973 and in December 2011 purchased the Our Lady of Lourdes Catholic Church on Twenty-first Street (*Historic Firsts* 92–93).

CHRISTIAN SCIENCE—1897

Regular church services began in Lewiston in 1897 at the home of Eva Kelly Mounce, who was the daughter of the city's first mayor, Dr. Madison Kelly. In 1899, Dr. Francis J. Fluno of Oakland, California, gave "the first lecture of its kind in the area" at the Nez Perce County Courthouse. The congregation became a branch of the "mother" church in Boston, Massachusetts, on January 13, 1900, and was holding its meetings in a small building on Main Street. The congregation completed Idaho incorporation in December of that year.

In January 1903, the group began holdings its services in a small building owned by local attorney and member James Elisha Babb at Fifth Street and Second Avenue, near the First Christian Church described below. The congregation finally erected its own church at 825 Seventh Avenue in 1908. The building was formally dedicated on August 8, 1920.

Daniel and Elizabeth White were longtime Lewiston residents. Born and raised in East Exeter, Ontario, Canada, Mrs. White arrived with her parents in Lewiston in May 1871 and finished her education in Lewiston schools. She married Daniel in 1877 and was instrumental in raising the funds for the purchase of the first school bell for the new public school building erected in 1881–82.

Daisy Babb was the descendant of *Mayflower* passenger Peter Brown and two Revolutionary War officers (*Hidden History* 93). Her father was a West Point graduate and a colonel in the Twenty-sixth Illinois in the Civil War. Her husband, James, came to Lewiston in 1891 on a business trip and was so impressed with the community that he moved there in 1892. A letter from Daisy expressing her concerns and observations of the 1892 Democratic

John and Ella Fix family, circa 1915. *Courtesy of Penn Fix.*

National Convention moved William Jennings Bryan to successfully lobby to allow her to attend the Democratic gathering in Chicago. Daisy then followed James to Lewiston that fall on the steamer *Almota*, the same boat to transport Lewiston's Company B to service in the Spanish-American War (*Hidden History* 72).

John Fix was born in 1847 Württemberg, Germany, and moved to Idaho in 1875. He served with Company E, Sixth Ohio Infantry, during the Civil War. John and Ella married in 1885 and moved to Lewiston that year. In 1897, she was a member of the first all-woman jury in Idaho and would visit the church headquarters in Boston headquarters several times over the coming years (*Historic Firsts* 95–96). Their daughter Katherine was one of Idaho's first tennis stars, winning multiple state and regional championships before and during World War I.

Baptist—1898

The genesis of Lewiston's Baptist congregation centered on the missionary work of "Father" S.E. Stearns, a circuit-riding minister who lived in Moscow, Idaho, and held meetings from Lewiston to Spokane in the 1880s. The *Home*

Mission Monthly (October 1881) reported that ten Baptists could be found in Lewiston. An old log church on D Street was reportedly used for infrequent services that depended on a minister's availability.

The congregation achieved official status in the fall of 1898 as result of the work of Gustave R. Schlauch, who held his first services in the Odd Fellows Hall near Sixth and Main Streets. In 1902, the congregation purchased the old Universalist Church at Seventh and Main Streets. In 1905–1906, a mission chapel was built at Twenty-second and Main Streets. The mission operated for several years as a Sunday school and was near the old Lady of Lourdes.

Fire destroyed the downtown church on April 12, 1908. The congregation accepted the invitation to use the new Christian Science church on Seventh Avenue and began work to purchase property on the corner of Eighth Avenue and Eighth Street, dedicating a new church designed by James Homer Nave on March 26, 1911 (*Hidden History* 107–114).

The most notable members of the early congregation were Henry and Annie Fair. Henry was an award-winning photographer who owned and managed the Art Store near the public school. Annie was a graduate of the New York Conservatory of Music and art teacher. Many of the most familiar images of Lewiston from the early twentieth century are Henry's photographs (*Historic Firsts* 45; *Hidden History* 40, 115).

First Christian — 1898

In May 1898, local members "secured the services of Reverend J.O. Davis, a preacher of ability and force, to be local pastor." He procured the G.A.R. hall at Seventh and Main Streets for meetings, which were only the first and second Sundays of the month. On March 6, 1899, James W. Reid, local attorney and chairman of the board of trustees at Lewiston State Normal School, appeared before the city council and presented an application for the purchase of a lot in the old cemetery (now Pioneer Park). The congregation wanted to build a church. The item was tabled. Plans were already underway to convert the old graveyard property into a public park, which occurred in June of that year.

Within weeks, the congregation purchased property on Second Avenue and began constructing a building, which can be seen in an image of the city taken in June-July 1899, as part of the commemoration to open the new

interstate bridge to Clarkston (*Historic Firsts* 103). The building is the oldest existing church still found at its original location.

In 1924, the congregation opened its new church in the 700 block of Seventh Avenue, near the Normal School. The original church building became the home of the local Lutheran congregation in 1926 and was dedicated as Trinity Lutheran, with the first services held on February 7. The Lutheran congregation in Lewiston dates from 1907, although irregular English Lutheran services were being held by June 1898 at the Presbyterian Church on Main Street.

In the early morning hours on August 4, 1929, Ol' No. 8 made the last run of any Lewiston trolley and was parked at the Clarkston terminus. Marcus Means, who first proposed and initiated streetcar service in Lewiston twenty years before, observed: "That's progress for you. The iceman thought he had a monopoly until they invented the refrigerator. The button lost out to the zipper." Interstate trolley service began in 1915 and ran along a four-and-a-half mile line from east Lewiston to Clarkston via the old interstate bridge. On the first day of service, riders had to spread sand on the rails to give the wheels enough grip to climb the steep grade of the span.

4
A WILLING SHEPHERD UNDER NO COMPULSION

Shepherd the flock of God under your care, serving as overseers, not under compulsion, but willingly before God; not for love of dishonest gain, but eagerly.
—*1 Peter 5:2 (New World Translation)*

The pioneer merchants who provided grubstakes and liquor to the transients briefly populating the city on their way to possible riches knew the inevitable—the halcyon days of the gold dust would pass, and the profits of that trade would evaporate. Only the hardiest remained when Lewiston struggled to keep families and fledgling institutions intact. That gloom had only recently begun to lift in July 1881, when a thirty-three-year-old minister speaking in a thick brogue arrived in Lewiston with his wife, two-year-old son and infant daughter.

John Douglas McConkey was born in Grays Abbey, Ireland, on February 29, 1848, to William and Margaret McConkey. Margaret bore William thirteen children between 1834 and 1860. Educated at "the national school," John served as an assistant instructor at the school before he was fifteen. He immigrated in January 1868 and was naturalized as an American citizen on March 20. Settling in New England, he taught school in Connecticut and New York until 1871, when he enrolled at Saint Stephen's College in Annapolis, New York. He was awarded an *artium baccalaureus* (bachelor's degree) in 1874 and matriculated to the Episcopal Theological School at Cambridge, Massachusetts, earning his bachelor of divinity degree there in 1876.

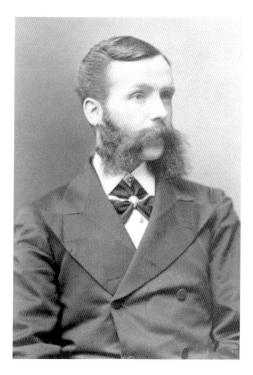

John Douglas McConkey, circa 1876.

Standing no more than five-foot four, John was soon ordained in the church diaconite (deacon) program and elevated to the priesthood, his first pastoral assignment being to Saint John's Church in Millville, Massachusetts, where he took over duties on October 14, 1876. A young woman in the congregation caught his eye—Anna May Joslin, a young schoolteacher and the daughter of James and Rosanna Joslin. Anna's father was a Bellingham, Massachusetts boot maker, Rhode Island native and Civil War veteran, having served with the First Rhode Island Cavalry and a survivor of more than twenty-five engagements from August 1862 to November 1864.

Born on July 29, 1853, Anna enjoyed the privileges of a good education for a girl of the 1860s and early 1870s. She moved to Woonsocket, Rhode Island, in 1871 to complete high school, before returning to Bellingham and entering Dean Academy (now Dean College) in nearby Franklin. For the reader who is not familiar with towns in New England, Woonsocket and Bellingham are only about eight miles apart. The short distances between small towns on the Idaho frontier towns would soon seem very familiar to Anna.

By the late spring of 1872, she had earned a teacher's certificate and was working in the Bellingham school district, where she would remain until mid 1875. When she left the district to return to Woonsocket, she asked for a letter of introduction from her superintendent, Dr. Roland Hammond, whose hand-written recommendation survives and tells us a great deal about Anna's personality:

> *Miss Anna M. Joslin, under my supervision, has taught in one of our public schools most of the time for three years, and has met with a commendable degree of success, and, so far as I have learned, has given good satisfaction.*

ELEGIES AND BYGONE PLACES

To a temperament naturally cool and collected she adds firmness and self-reliance, and I think would be likely to succeed in any school which she would be willing to undertake.

I cordially recommend her to the favorable notice of those in want of teachers.

By 1877, Anna had moved back to Bellingham and experienced a series of events that would bring her to Lewiston four years later. An Episcopal convert, Anna was baptized at the Millville church on May 6, 1877, and confirmed on September 23. John officiated at both events. Their romance was, without doubt, already months old and resulted in their marriage on November 6 in Millville. He was twenty-nine and set upon his career; she was twenty-four. The closeness of the date of her baptism to that of their marriage would lead one to believe that Anna's baptism might have been a pre-requisite for their nuptials.

The couple had little time to settle into the calm lifestyle of a New England minister. On February 16, 1878, John and a now-pregnant Anna left New York City's Pier 17 aboard the steamship *Oregon* for a sixty-five-day journey to Portland. A church in the Washington Territory awaited his guidance. One can only imagine Anna's discomfort on the 1,600-mile voyage, which John chronicled for friends back home in *From New York to Portland, Oregon, via Straits of Magellan, with a History of the Voyages, Scenes, Places, Incidents and Notes of the Journey*. In the account, John mentioned that "some of the persons who had been emaciated by sea sickness were brought on deck and they were so thin that they cast no shadow." From Portland it was another trip up the Columbia to Celilo Falls and then overland to Walla Walla aboard a train whose passenger car was so open to the elements

Anna Joslin McConkey, circa 1877. *Courtesy of DeLayne Whipple Brown.*

that dust and sand "found its way through every crevice, so that we were completely covered with it. I could write my name anywhere on my coat." John and Anna found Walla Walla to be a thriving town in the Washington Territory. His new assignment was Saint Paul's Church, a congregation founded the same year and by the same missionary as Lewiston's Church of the Nativity (*Historic Firsts* 55–56). The church building had been constructed in 1873 with a 103-foot spire that commanded the town's skyline.

Unlike early Lewiston, Walla Walla had a well-developed religious community when the McConkeys arrived: eight churches and a convent. However, not all was what it seemed, as John would observe:

> *The Walla Wallians are by no means what the many spires would lead us to suppose. They are wholly bent on making money. They are not religious. I cannot say they are opposed to religion, but most certainly there is a very strong indifference manifested. They tolerate it as a good institution for preserving peace and for keeping their wives from prying into their business, and will support it liberally so long as it does not interfere with their Sunday traffic.*

He lamented that in many instances church attendance "amounts to nothing more than man-worship. It is love for the minister, not love for Christ, which makes and retains many members of a church." John was learning the provincial realities.

On July 15, 1878, John got his first taste of territorial politics. Washington was holding a constitutional convention in Walla Walla, and he was asked to give the invocation on that day to ask for guidance over the proceedings. The convention was an odd affair, embroiled in fractious regional disputes. The counties of north Idaho wanted out of the Idaho Territory and even sent Lewiston newspaper editor Alonzo Leland as a non-voting delegate to the convention, which accepted him even though he did not live in the Washington Territory. It got even stranger. On November 5, 1878, when Washington Territorial Legislature placed its first constitution before the voters, Lewiston and other towns in north Idaho were included in the balloting. Washington was petitioning for statehood, and the four northern, or "panhandle," Idaho counties were to be included in the new state. Idahoans voted 96 percent in favor of the idea, more so than did residents of Washington. The proposal failed in Congress, but it was undoubtedly at the convention that John made his first acquaintance with Lewiston's bulldog editor.

John Douglas McConkey Jr. was born on September 10, 1878, and was apple of his father's eye.

John's tenure at Saint Paul's lasted a year. Quite possibly he was laboring under the same woes as those of Lee Fairchild, who "could get along very well with the sinners, but had trouble with the saints." John set to work establishing a boys' school and expanding the Episcopal missionary work in the region. The March 29, 1879 issue of the *Churchman* ran an advertisement for John's book, which was on sale for $0.50 ($12.50), stating "the proceeds of the sale of this book will be applied toward building a boys' school in Walla Walla, Wash. Ter." That spring, John completed the requirements for his master's degree from Saint Stephen's College.

Anna's older brother Herman Joslin arrived from Massachusetts by the summer of 1880 to stay with the family. He would later play an important role in his sister's life. It was about this time when Lewiston began to beckon to John and his family. John had mentioned Lewiston in his recollections of his voyage from New York, but only in the context of distances from various points in his travels up the Columbia River aboard the recently launched *Annie Faxon*, which would be destroyed on August 14, 1893, just downstream from Lewiston, when its boiler exploded, killing eight and injuring fourteen.

Daniel S. Tuttle, Episcopal Bishop of Utah and Idaho, had been visiting north Idaho in 1881. He found that Lewiston needed a "resident Pastor" and knew that John had grown wearisome of Walla Walla. In July, John packed up his family, which now included their six-month-old daughter, Hattie May, and embarked on a journey to Lewiston's Episcopal mission. The congregation was not new. On Christmas Day 1864, local Episcopalians met for their first services, presumably under the direction of Reverend J. Michael Fackler, who was the director of the Missionary District of Idaho and had only recently founded a congregation in Boise. As a consequence, the mission was named the Church of the Nativity and was north Idaho's first. However, Lewiston's Episcopalians would have no resident minister for nearly seventeen years. John was the first permanent rector for the congregation, which upon his arrival, still had no church building of its own.

Sometime in 1876 or 1877, a few members constructed a simple log church on D Street, where the new Lewiston City Library now stands. The structure was still in use but hardly adequate. After all, it was a primitive structure. John conducted his first wedding on August 4, 1881, to unite Harry Wilson and Emma Bowers. A log church did not seem appropriate, so the couple wed at the Raymond House.

John accepted the hospitality of the Universalist congregation to use their church at Seventh and Main Streets. He performed his first four baptisms there, as well as one wedding. This working arrangement came to light as

Daniel Tuttle, circa 1888. *Courtesy of the Episcopal Diocese of Idaho.*

a result of research into the earliest documented funeral held in Lewiston, that for Evangeline Vollmer, eldest daughter of John and Sarah Vollmer, on September 28, 1881. The funeral was the first entry in John's ledger of church deaths. By 1883, the ledgers were listing baptisms and weddings in the "guild hall," where the women of the congregation held their meetings, evidently under Anna's leadership.

A month before Evangeline's burial, John's hand can be seen in the city council's passage of Ordinance 45 on August 15, in a vote that split the body. The ordinance was Lewiston's attempt at a "blue law." Only shops selling bread, fresh meat and drugs or hotels and restaurants could be open on Sunday. Within a week, a citizens' petition reached the council demanding repeal. A vote to amend the ordinance split the council, forcing mayor Sylvanus Hale to vote against the motion. The statute stood but proved very unpopular and was finally repealed on October 14, 1895, only to be resurrected in April 1899.

One of John's first church-related initiatives had been to purchase the building on D Street, and the lot on which it stood, to give the congregation a permanent home. However, it was reported in 1883 that "on this property there is yet a debt of $800 [$19,000 today], which his people are struggling to pay." Daniel Tuttle visited John and stayed for two weeks that year. He later commented: "[His] patient fidelity at Lewiston refreshed my soul, repaying me well for the long journey needed to reach him." Tuttle stayed in the "annex" (rectory) of the log church, which was proving to be a white elephant for the parishioners. The "annex" may have been the women's

"guild hall," which the March 1888 Sanborn map shows to be not much more than a closed-in porch. Something else was needed.

In the meantime, John proved to be a champion of the Lewis Collegiate Institute, which opened as Idaho's first college in 1882, under the auspices of the Methodist Church (*Historic Firsts* 77–78).

Quite aside from the financial troubles associated with building a congregation, 1883 started out on a tragic note for the McConkeys. John Jr. became ill and died of whooping cough on January 26, at the age of four. The congregation was still grieving the loss of infant twin babies Clyde and Claude Kester, who died of whooping couch within days of each other about a month previously. Now the pastor was conducting a funeral for his own son. The little congregation again raised their voices in Hymn 262, quoted here directly from Anna's personal hymnal, the one given to her by John on October 4, 1877, as a gift, the one she held at the funeral for her little boy.

> *As the sweet flower that scents the morn,*
> *But withers in the rising day;*
> *Thus lovely was this infant's dawn,*
> *Thus swiftly fled its life away.*
>
> *It died ere its expanding soul*
> *Had ever burnt with wrong desires.*
> *Had ever spurn'd at heaven's control,*
> *Or ever quenched its sacred fires.*
>
> *It died to sin, it died to cares,*
> *But for a moment felt the rod:*
> *O mourner, such, the Lord declares,*
> *Such are the children of our God.*

Little John's burial would have proved to be a difficult task. Lewiston was experiencing a long stretch of sub-zero weather, with temperatures dipping as low as negative fifteen degrees Fahrenheit (negative twenty-six degrees Celsius).

Since the city's founding, more than one wife has wanted to leave as soon as she set foot in Lewiston. In the best of years, the town can look like an oasis surrounded by high desert. If Anna had any misgivings about whether John's assignment to the town was worth the emotional and cultural costs, they

The McConkey children: John Douglas Jr. (left, top), circa 1881; Hattie (above), circa 1884; Isabell (left, bottom), circa 1890. *Courtesy of DeLayne Whipple Brown.*

were probably greatly reinforced by the summer of 1883, when measurable precipitation stopped on June 4. By the early 1870s, the need for a reliable water supply system led to the construction of what most people called "the ditch," a plank-covered sluiceway that carried water from a point four miles upstream on the Clearwater and wound along the base of the Normal Hill bluff. Horses broke through the covers. The ditch stank from waste and the carcasses of dead animals; maintenance was

sporadic. On several occasions, the waterway ran dry. Large wheels were constructed to raise water into reservoirs and provide irrigation to gardens. In 1883, Lewiston withered for more than three months before the rain returned in September, a record ninety-two days.

Crepe tied with white ribbon again hung from the family's front door in April 1884. Anna had given birth to a second son, whom they named Henry Cook, the namesake of Anna's uncle with whom she had lived as a teenager. The infant lived just thirty-six hours, dying on April 30. Again John officiated at his son's burial in the Masonic Cemetery (now the site of the old Carnegie Library). Hymn 262 was sung for another McConkey child. In *Hidden History of Lewiston* (24), I quoted from Jay Neugeboren's *An Orphan's Tale*. His comment is no less important here:

> *A wife who loses a husband is called a widow. A husband who loses a wife is called a widower. A child who loses his parents is called an orphan. But there is no word for a parent who loses a child, that's how awful the loss is!*

Twenty-one burials are recorded on the first page of his church ledger, covering the period from September 1881 to September 1884. Of that number, fifteen were for children under the age of ten. John and Anna's faith must have been sorely tested. That age-worn ledger, now in the archives of the Church of the Nativity, produced a startling discovery.

On May 25, 1888, John conducted the funeral service for James Binnard, who had died in Palouse City, Washington Territory, and was to be buried in Lewiston's old cemetery. Most of Palouse City had burned to the ground on May 17, and James had worn himself out trying to save his business and those of others: "Forgetting his own loss and realizing only the misfortunes of others, he zealously threw himself into the work of assisting his fellow citizens through their difficulties. So intense was his zeal that he overestimated his physical endurance." What could be so important about this account?

James was Jewish, and John made a specific reference to the "Jewish Cemetery." As noted in chapter three, the closest rabbi in 1888 was three days away in Portland, and Jewish burials are held before sunset on the day of death. That small fact tells us that James died after sunset on May 24. He executed his will on May 23, possibly making the arrangements to have his body transported the fifty miles to Lewiston as soon after his death as possible to satisfy rabbinical law.

The service for James Binnard was not the last time John served the local Jewish community, for whom he conducted burials on November 22,

1896 (Isaac Grostein) and November 23, 1898 (Abraham Binnard, James' brother). While not documented, John might well have conducted the services for Moses Grostein (November 1886), Bena Grostein (1888) and Birka Binnard (September 1887), all of whom, like James, were buried in what is now Lewiston's Pioneer Park.

In one final revelation, John's old ledger carried a simple notation with two burials—"R.C." Lewiston did not have an available Roman Catholic priest when twelve-year-old Josie Ramaris and nine-year-old John Henry Stainton died in June 1883 and February 1884, respectively. John was proving to be "all things to people of all sorts."

The issue of church funding raised its head again in November 1884, when the Ladies of the Guild asked the city council for a donation to pay off the balance of the note on the old D Street building. The request was tabled and does not appear in any subsequent council minutes.

The spirituality of Lewiston Christian residents impressed John little more than that of Walla Walla's inhabitants. In the summer of 1885 he wrote in a letter:

> *Here will he find a free and easy people. They are perfectly indifferent in the matter of religion and religious teaching. If there be preaching or religious teaching, well and good. They will not seek it, yet when it comes they will not directly oppose it. They regard religion as a good thing in its place, but not indispensable, for they live by the theory that they can subsist without it, although when they come to die or be buried they cannot do without its consolation and final committing benediction, for they must, no matter what kind of life they led, have a clergyman to officiate at their funeral. Only a short time ago we were called upon to officiate at the funeral of a horse thief who fell dead from the bullet fire by the sheriff, whom he separately resisted. Not long since, also, did we have the call to a similar service over the remains of two men who, it was supposed, had been foully murdered, but afterward it was declared a Kilkenny fight in which the one killed the other (*Hidden History *139).*

John's work as a school master resurfaced in Lewiston in November 1885, when he announced that a "select Parish school" would open on November 16. He promoted the "advantages of such a institution under the management of a through scholar and excellent disciplinarian." Just what the local public school officials thought of the idea is not known. Lewiston had only recently opened a stately three-story building for grades one through eight (*Historic*

ELEGIES AND BYGONE PLACES

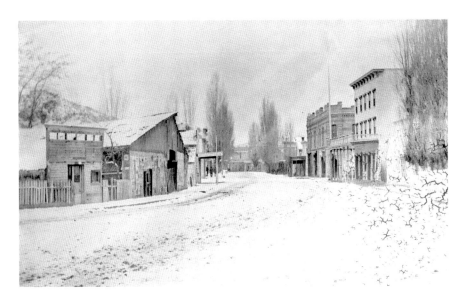

A Lewiston street scene, December 1885.

Firsts 86). John could find a catharsis for his grief over losing two sons within fifteen months by increasing his daily activities. The same could not be said for Anna, and her health began to fail. By the fall of 1885, it was clear that she needed to leave Lewiston for a warmer climate. Another cold Lewiston winter might well prove fatal. Her brother Herman Joslin opened his home to her in San Francisco. The November 19, 1885 *Nez Perce News* reported that she had left on a recent steamer: "We hope [she] will return to us with improved health."

Anna's departure was especially painful for John because four-year-old Hattie accompanied her mother to California. While John regularly wrote to Anna, it is his miniature letters to Hattie that have survived. In what seems to have been one of his first, dated November 30, 1885, he wrote:

> *I want to tell you that the cat is awful lonesome....No little Hattie to say good night or to kiss me. I think you should have staid* [sic] *with me when I asked you to. Don't you want to come back to your dear papa?...I am afraid it is going to be anything but a happy Christmas this time.*

Anna and Hattie's absence proved to be lengthy, and Lewiston was not a healthy place. In late January, John wrote to Hattie that "everybody has bad colds, and the whooping cough is prevalent. Also some disease which chokes

people all of a sudden." Those words must have been painful for John to write, given his memories of little John's last days just three years before. On February 5, 1886, he mournfully penned a short verse to his daughter:

> *I write tonight, my Hattie dear,*
> *The tears are in my eyes,*
> *To tell you everything I might*
> *But do not think it wise.*
> *…*
> *We shall meet I am sure*
> *When the snows are all o'er,*
> *If not in this burgh,*
> *On the evergreen shore.*

Anna must have sensed that John was becoming deeply depressed and sent off a note that made its way into the local newspaper, which reported on February 11 that she "is much improved in health." We can only imagine the joy of reunion on Friday, March 26, when Anna and Hattie alit from the steamer, "looking the picture of health," and into the arms of their husband and father.

In their absence, John had stayed busy. The Episcopal congregation in Moscow, Idaho, was formed in 1888, but prior to its formal organization, John had been visiting the community "in the interests of this church." Duties to solemnize marriages would take him, over the years, as far away as Mount Idaho, near Grangeville, a journey of some eighty miles.

By the summer of 1885, John was advertising in national journals for donations to build a proper church. "We need and want to build a church." The church's national missionary society publication commented:

> *The Rev. J.D. McConkey, for seven [sic] years the Church's missionary at Lewiston, is now making an effort to raise funds among his people with a view to building a church. His subscription committee is now at work and meeting with encouragement. His long, patient, and faithful devotion deserves a generous recognition from the people of Lewiston. When all has been done at home that we have a right to expect, then the Bishop would be very grateful if his friends would put it in his power to assist these worthy people in the accomplishment of their object.*

The rector had his eye on what he thought was the perfect site. The corner of Main and Eleventh Streets was already the site of two large churches for

the Methodist and Presbyterian congregations and was commonly called "Piety Corner." The paper trail of the deed abstract is a tale in itself. After the 1874 township survey, all parcels in the city were conveyed to Dr. Henry W. Stainton, who was Lewiston's mayor at the time (*Historic Firsts* 16–17). Located near the eastern city limits, the lot in question was originally owned by local carpenter Matthew Chambers, by whose name Eleventh Street was known for many years (*Hidden History* 105). In August 1882, the property came in the hands of Isaac N. Hibbs, who would become Lewiston's postmaster in January 1884 and soon spark a scandal to rival any in Lewiston's colorful history (*Historic Firsts* 25–26). Hibbs sold the property just a few weeks before disappearing from Lewiston and fleeing to Canada with his ill-gotten gains from postal fraud.

Negotiations on the property were finalized with owners John and Emma Chapman on May 14, 1890, with a purchase price of $1,200 ($31,000). The very same day, John executed a mortgage loan with the Chapmans, who were pillars of the Presbyterian Church, for $500 ($13,000) to pay off a lien on the land and purchase construction materials. Work began immediately, just

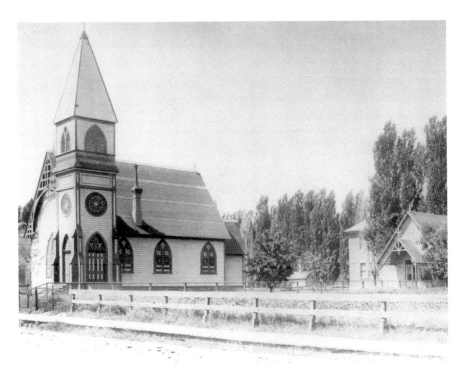

Episcopal Church, 1895. *Courtesy of the Church of the Nativity.*

south of the Methodist and Presbyterian churches, and would continue until 1891. In an ironic twist, Chapman would twice be Lewiston's postmaster, albeit a much more honest one.

Leading up to the church-raising, John was riding the circuit in his role as the Episcopal rector. The *Lewiston Teller* reported on August 24, 1888, that John had arrived back from the gold fields at Warren, Idaho, and "speaks very highly of the hospitality of which he was the recipient while in the camp. He held religious services on Sunday and was very gratified at the large audience that assembled on the occasion and proposed to repeat the trip and stay longer next summer." One cannot help but be reminded of the scenes in the popular motion picture *Paint Your Wagon* and the short-lived effects traveling ministers had on the lives of hardened miners who survived day after day with the tedium of trying to rake out of the river banks a meal, a drink at the local saloon or some time in a brothel.

John's connections to Lewiston's cemeteries were more than coincidental. On November 14, 1888, he conducted the first graveside service the city's new cemetery, now called Normal Hill Cemetery. Charles Wiggin had died of spinal meningitis and was laid to rest in the Odd Fellows section. John would also conduct the service on September 25, 1889, for John Menomy, the Lewiston undertaker who had laid out the cemetery (*Hidden History* 66). Menomy is mentioned in two of John's letters to Hattie, having given her a doll for Christmas in 1885, "a fine one, black hair and blue eyes. Oh, just a beauty."

The McConkeys welcomed their second daughter, Isabell Eldora, into the family in December 1889.

John's success at finally building a proper church for the Episcopalian congregation was followed in the 1890s by a flurry of activities. In 1893–94, he served as the city magistrate, and for a time, as president of the Lewiston School Board, as well as a justice of the peace.

In August 1893, John learned that his mother, Margaret, had died.

John assumed new and different duties as a spiritual leader on October 10, 1895, when he was appointed by Governor William McConnell (*Hidden History* 85) as a major and chaplain for the First Regiment, Idaho National Guard.

You will recall that John had founded and operated a boys' school in Walla Walla during his tenure there. Saint Aloysius Academy, a Catholic school that once sat at Fifth and D Streets, was in operation but was having difficulty maintaining a teaching staff. The February 1896 Sanborn map of Lewiston shows the "Episcopal Chapel School" and "school room" next to the parsonage on Chambers. The venture did not survive John's retirement, being noted as a "Sunday School" in the 1900 map of the neighborhood.

ELEGIES AND BYGONE PLACES

The expense of raising the new church on Eleventh Street was a puzzling issue for the congregation. John P. Vollmer and William Kettenbach Sr. were pillars of the congregation and were wealthy beyond the dreams of virtually every other Lewiston resident at the time. Vollmer was, by the late 1880s, Idaho's first bona fide millionaire (*Historic Firsts* 87–90). However, in early 1897, John finally put out an appeal for $500 ($14,000 today) in donations to retire the debt on the building.

As mentioned above, John served on the school board. On September 5, 1898, the trustees hired him as district superintendent with a salary of $30 ($850) a month. While this might seem an isolated fact, it is an important discovery. Sources dating back as far back as 1911 list Robert N. Wright as the district's first superintendent who did not also serve as principal, beginning in the fall of 1899. Those references are wrong. The report of that school board meeting is clear:

> *In the past the superintendency of the schools of the district was included in the duties of the principal, and the results have not been satisfactory. Mr. McConkey will instruct only one hour each day in Latin, and the supervision of all the departments will receive his strict personal attention. He is an accomplished educator, and the school board has been fortunate in securing his services for such a moderate consideration. The public school service will be greatly benefited by this new arrangement.*

John had a short walk to work; the school was located in the next lot, west of the church. More importantly, he proved to be a role model and benefactor for several men whose names would resonate in the city's history.

By the spring of 1899, his constant labors over the previous eight years had taken their toll, and John retired from the pulpit. April was a particularly taxing month. In one of his last official ecclesiastical duties, he conducted the April funeral for Major Edward McConville, who had been slain in combat in the Philippines (*Historic Firsts* 101–02). So many mourners attended the graveside service that it is a wonder that anyone heard John's comments.

He would not remain inactive in retirement. When the Idaho State Medical Society held its seventh annual meeting in Lewiston on October 5, 1899, John was called on to deliver the invocation. A longtime Mason, John served several terms of the secretary of the local Thirty-third Degree Scottish Rites Lodge.

Although the family is still listed as living at the parsonage in the 1900 census, John soon needed to rent a home to make room for the new rector.

In October 1906, John purchased two lots on Normal Hill from Christian Osmers, co-founder of the Owl Drug, for $400 ($10,300), at an address once found at 1716 Second Street and had a modest one-story home built on the property.

By 1913, John's health was very poor, and he died on August 24, a mere three weeks before his daughter Isabell married Al A. Ruland in a Lewiston ceremony. Death visited the family again on May 30, 1915, when Isabell delivered a stillborn daughter, whom they named Isabell. In 1920, Anna; Hattie; Isabell, now divorced; and a two-year-old granddaughter, Leonora, were listed as living at the Second Street home. Anna died on April 19, 1922. Friends remember whispers of an illegitimate child that broke up Isabell's marriage. Daughter Hattie never married and lived out the rest of her life at the family home, passing away in December 1965. Isabell followed in 1971.

In 1920, the church that John worked so diligently to erect had its stained-glass windows carefully removed before the building was sawn into sections and pulled by horses and steam winches to be reassembled and remodeled after a plan by Lewiston architect Ralph Loring at Eighth Street and Eighth Avenue. There, it remains Lewiston's oldest house of worship and a landmark and legacy of a willing shepherd under no compulsion, a man whose grave and those of his family are not even marked in Lewiston's Normal Hill Cemetery.

> In one of the oddest marriages to take place in Lewiston, forty-four-year-old widower Abram deJong, of Ellensburg, Washington, was married by proxy to Adelia Reimer, of Velbert, Germany, on February 8, 1951. They had met a year before, when she visited relatives in Ellensburg. Probate judge Elmer Boise performed the marriage, with deJong's daughter acting as the stand-in bride. Attorney J.H. Felton was "best man." Thomas W. Campbell was "bridesmaid" and the second witness. The marriage was carried out in Idaho because Washington did not recognize proxy marriages. Such marriages are no longer legal in Idaho either.

5
POSTCARDS FROM OUR FATHERS

Normal Hill

When the Washington Territorial Legislature chartered Lewiston on January 15, 1863, the city limits reached to what is now Eleventh Avenue (*Historic Firsts* 38–39). The earliest references to the southern part of town came in 1876, when several "lots of acres" were laid off, one for a Chinese cemetery and another for a proposed city park (*Hidden History* 118–19). Although local residents owned property on "the plateau," the land was not properly platted until the spring of 1883, after the Lewis Collegiate Institute requested a survey for the site of a new college building there (*Historic Firsts* 77–78). In March, the college was granted land at a rate of $25 ($625) an acre. J.W. Bigsley and Company had proposed bringing water to the section in February, but it would take more than a decade for service to be brought into homes. In July 1890, the Lewiston Water and Light Company was "relieved" of its responsibility to maintain water pressure "south of the bluff," although the company did assume the city's interests in providing water to the new cemetery.

A major development came in May 1890, when the Park Addition ("Lot 5 of Acres") was surveyed. That plat took in the area bounded by Seventh and Eleventh Avenues and extending from Fifth Street to Fourteenth. In December, the area west of Fifth Street and north of Fourth Avenue was set aside for the dedication of streets. The first home on the plateau was built during the winter of 1891–1892 and still stands in the 200 block of Fourth Street.

Residential development expanded dramatically in the decade after the city conveyed ten acres from the Park Addition on February 13, 1893, for

Two sections of a four-section city panorama, circa 1903.

use as the site for Lewiston State Normal School. In April 1894, the council received a citizens' petition to construct a stairway from Main Street to the crest of Fifth Street. This path is still used by college students walking from Clearwater Hall to the campus.

By early 1898, people were advertising lots for sale on "Normal Hill." The first use of that sobriquet in city council minutes occurred on September 7, 1899. On March 13, 1900, the council acted on a petition to open Prospect Avenue as a "public highway," and the December 1900 Sanborn map shows the street reaching Seventh Avenue. With streets and avenues in place, Normal Hill became the place to build.

ELEGIES AND BYGONE PLACES

Built in 1907, the original city band shell once sat where the restrooms are now located in Pioneer Park and in the area where the old Jewish cemetery was likely located. A serving president of the United States has visited Lewiston only once and that was on October 7, 1911, when William Howard Taft spoke to a crowd estimated to be fifteen thousand people filling the park to hear his comments. Arriving by a train pulling his custom-fitted car, "The Ideal," Taft was taken by automobile from the new depot at Main and Thirteenth Streets to the Snake River Bridge, up to Prospect Avenue and then to the park, where he was greeted by a delegation from the G.A.R. at the park's gates and escorted to the band shell by local Boy Scouts. Cries of "Hello, Bill" could be heard from the crowd. In his address, he told the audience that his visit to Lewiston was a great pleasure, and he felt honored

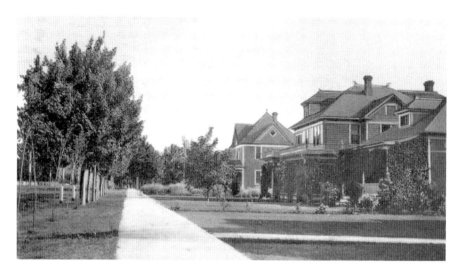

Fifth Street, circa 1906. The postcard carries a backhanded compliment: "You would think this is a pretty town by the looks of it." *Courtesy of the Lloyd Futter Collection.*

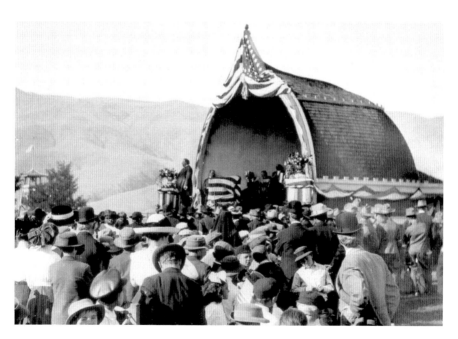

October 7, 1911. President William Howard Taft speaks to a large crowd of Lewiston onlookers at the old band shell in the Fifth Street Park (later Pioneer Park).

by the greeting that had been given him. Over one thousand schoolchildren were among the crowds. In his speech, Taft mentioned that not everyone approved of his policies, but people listened with great respect. At the end of his comments, he waved and said, "Well, good-bye all" (*Hidden History* 77).

In the summer of 1950, the Elks Lodge began discussing a replacement band shell. The project faltered, and the shell was demolished in 1956. A new shell was erected at the north end of the park in 1989 as part of the 1990 Idaho statehood centennial.

Construction on Normal Hill began in earnest after the normal school campus opened in the summer of 1896. Two of the earliest surviving structures from the building boom are the old Supreme Court Building and the former Carnegie Library (*Historic Firsts* 116–117). The photograph shown here is of special note, not because of the subject matter but for the location from which the image was captured. The photographer may well have been Harry Barnett.

An Irish immigrant who came to the United States at the age of seventeen and to Lewiston in 1872, Barnett took up the insurance business, representing

Idaho Supreme Court Library and the south end of Fifth Street Park (later Pioneer Park), circa 1910.

London Fire Insurance Company. In 1910, he consolidated the Nez Perce County Abstract and Lewiston Abstract Companies to form North Idaho Title and Abstract Company, retiring in 1917. Safeco purchased the business in 1974. He also served two terms as city assessor and four years as county auditor. The punchline? Barnett's wife, Elizabeth "Lizzie," was Perrin Whitman's daughter. Harry and Lizzie were the great-grandparents of Grace Slick, lead singer for the popular band Jefferson Airplane (later Jefferson Starship) and one of America's first female rock stars.

Moving Lewiston High School to Normal Hill in 1904 created many opportunities for the student body (*Hidden History* 33). The new building held physics, chemistry and anatomy laboratories on the third floor. The first class to attend school for twelve years had just graduated the previous spring, and by 1909, the school district had purchased two adjoining city blocks to allow for additional buildings to accommodate an expected growth in enrollment, which occurred just prior to World War I.

The school fielded several athletic teams soon after the 1904 opening of the school. The first athletic field stretched north from Eleventh Avenue between Twelfth and Thirteenth Streets. The high school tennis courts now take up the south end of the old field. High school baseball, football and track teams used the field until 1934, when a new facility opened at Fourteenth Street and Eleventh Avenue (*Historic Firsts* 131).

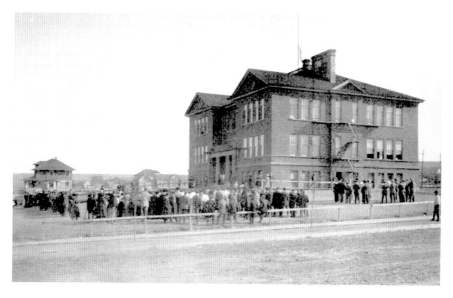

The opening ceremonies at the new high school, September 1904. *Courtesy of the Lewiston High School Archives.*

ELEGIES AND BYGONE PLACES

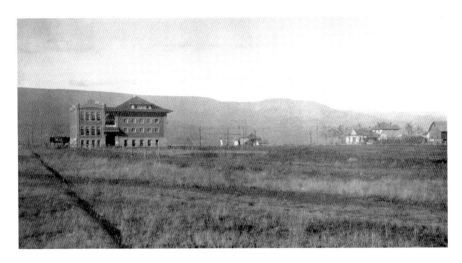

The high school athletic field, 1910. *Courtesy of the Lewiston High School Archives.*

A parade that included the American Legion drum and bugle corps, veterans of the Spanish-American War and World War I, various bands and floats wound through the business district and then to the new field during the dedication festivities, in 1934, which coincided with Armistice Day. The Lewiston–Walla Walla football game began at 12:00 p.m. During the opening ceremonies, S.E. Caple dropped the football used in the game from an airplane owned by Bert Zimmerly (*Historic Firsts* 146–147). In 1936, Lewiston students would name it "Bengal Field."

The new field has not always been to the liking of the neighbors. On July 7, 1939, the Idaho Supreme Court sided with five property owners and ruled that the Pioneer League had to refrain "from causing the lights to shine into and on appellants' premises so as to interfere with their sleep...from allowing balls to be knocked or thrown onto appellants' premises...and to desist from noise preventing sleep after 10:00 p.m." The Pioneer League first began service in 1939 as a Class C minor league with six teams: Boise, Lewiston, Ogden, Pocatello, Salt Lake City and Twin Falls. The baseball stadium was demolished in 1975 (*Hidden History* 95).

For other images from this region of Lewiston, see: *Historic Firsts*: 105, 117, 128 and 139. *Hidden History*: 14, 21, 25, 103, 110–11, 113 and 121–23.

6

THE PASSING TRIBUTE OF A SIGH

Yet even these bones from insult to protect,
Some frail memorial still erected nigh,
With uncouth rhymes and shapeless sculpture decked,
Implores the passing tribute of a sigh.
—Thomas Gray, "Elegy Written in a Country Churchyard"

Readers of this trilogy will remember the various references to Lewiston's first cemetery, which was located on the site of what has been known as Pioneer Park since the mid-1930s. I myself have often referred to how they "moved the cemetery" in the 1890s. By my own admission, such an assertion is a clear overstatement of the real truth, and I will no longer use the expression, not wanting to give life any longer to folklore clearly meant as a cover for ineptitude. Therefore, allow me to tell the full and unvarnished story, one that will heighten your appreciation when you visit the park on a warm summer evening to hear a concert or lay out a picnic.

The Earth is a veritable cemetery. One study has calculated that as many as one hundred and six billion people have populated our planet. The implications are staggering. By that estimate, nearly 95 percent of the world's historical population lies buried somewhere. Throughout history, men and women have created places for their dead, some in an effort to safeguard the remains, some to keep the memories alive. Many built monuments to last for centuries. Others, like Idaho's native peoples, consigned their dead to the earth beneath rock cairns that require an expert eye to distinguish

ELEGIES AND BYGONE PLACES

A home funeral, circa 1890. *Courtesy of Vassar-Rawls Funeral Home.*

from the natural topography. Regardless of their theologies, families have always sought some means to dignify the legacies of the lives they have so sadly lost. This fixation on commemoration and maintenance of the dead has never applied only to humans. For example, it was reported in early 2013 that a catacomb near Saqqara, Egypt, held nearly eight million animal mummies. In 1896, Hartsdale, New York, established the world's first pet cemetery, which now holds the remains of 80,000 animals on grounds so exquisitely manicured that from a distance you would be hard-pressed to distinguish them from a human cemetery. Many states have granted cemeteries permission to bury humans next to their pets, in what some call "gardens of loyalty."

The word cemetery reflects an ancient, hopeful image. Derived from the Greek word *koimeterion*, which is often translated as "sleeping room," a cemetery is a resting place. Cemeteries were considered sacred spaces where the dead awaited rebirth. For many Christians, this concept was translated into specific burial rituals, including the placement of the deceased on his back with his head to the west, so that at the resurrection he would rise to meet Christ coming from the direction of Jerusalem. In cemeteries throughout the nineteenth-century United States, from crowded cities to grassland prairies, rows of graves were aligned north to south, with the inscriptions placed on the west side of markers, leaving no one with an excuse for stepping on the graves' inhabitants.

It was in this context that the first burial took place in Lewiston, Idaho Territory, probably by the summer of 1861, for a victim of violence. A site

E.B. True city survey, Sheet 1 (detail), 1874. *Courtesy of the Nez Perce County Auditor and Clerk.*

on the edge of the bluff overlooking the town served the purpose. No one else wanted the land. It had no water supply and was barely accessible. Four murders were committed in a two-week period in Lewiston in 1861. In one incident, two masked men entered a house in December and, in spite of

resistance, carried off $500 ($13,000), killing one of the inhabitants. Before the issues of *The Golden Age* began to appear in August 1862, reports of deaths and burials are anecdotal. Indeed, of the first eight burials recorded in the reconstructed graves registry for Lewiston's first cemetery, five are for "unknowns." By 1864, Nez Perce County was funding burials for indigents. Evidence indicates that the 1862 burial of Annie McNeil was the first for a Lewiston child, at a time when few children lived here. Although births undoubtedly occurred in the town during those early years, the first documented reference to a birth in the city was July 7, 1865 (*Historic Firsts* 57–58; *Hidden History* 54a).

When the city's survey to achieve town site status was approved in the spring of 1875, the *de facto* cemetery became the official graveyard on the plat map, with an area of just over eight acres laid off on June 22. As more than fifty people had already been buried there, the decision was hardly surprising. Even the pioneer Chinese cemetery got a proper deed in November 1876 (*Hidden History* 118–19).

By January 1876, citizens were petitioning the city council to fence in the burying ground. Mourners frequently had to clear the cemetery of cattle to conduct a burial. The proposal suffered the same fate as many good civic projects: assignment to a committee. Then the Nez Perce War came along in the summer of 1877. On June 17, the council decided that "our mutual safety" necessitated the excavation of rifle pits along the northern edge of what is now called Normal Hill. One of those pits was situated among the Masonic graves. Its outline can still be found near the old Carnegie Library. You can bet that no superstitious man stood guard at that post. The very fact that the rifle pit was excavated at the north end of the cemetery speaks to the general lack of priority that the graveyard held in the city's collective mind. It would take repeated citizen complaints to make the necessary changes.

The issue finally came to a head in 1879, by which time the cemetery was the resting place for more than one hundred people, including Oregon pioneer Robert "Doc" Newell; his wife, Rebecca; and Catherine McGrane. Rebecca's burial, on May 14, 1867, marked an important date in the history of the cemetery. While many burials had taken place prior to her interment, her gravestone is the oldest surviving link to what one would have seen in the old cemetery when walking among its graves.

An Ohio native, Rebecca became Robert's second wife in 1846. His first wife, Kitty, was the daughter of a Nez Perce sub-chief. Robert had been instrumental in the formation of the territorial government of Oregon. Newell moved to Lewiston late in life to be near his Nez Perce relatives

LOST LEWISTON, IDAHO

Lewiston, summer or early fall, 1879. *Courtesy of the Arthur Andrews Collection.*

and friends. He worked as a special commissioner and interpreter for the tribe, which ceded land to him near the confluence. A government patent confirmed his ownership in 1868. He died in November 1869 and was buried next to Rebecca. Catherine McGrane moved to Lewiston in 1869 and died in 1877, leaving her husband, James, and five children.

City fathers moved slowly in making a decision on a fence. In May 1879, they sought to find out how much a fence would cost. The council was hardly enthusiastic about the project. Eight acres is a lot of ground. The city clerk recorded that the finance committee was directed "to pass around a subscription list to see what money can be raised for that purpose." Later that year the cemetery got its fence, which amounted to 1,790 feet and cost $363.26 ($9,000). The fence would have been much longer if the cemetery had not been situated on the edge of a steep bluff. No cow was going to scale that precipice, and I do not say this in jest.

Lewiston had made attempts to control animals, but they were largely lip service. Enacted on July 1, 1872, Ordinance 5 prohibited swine from running through the town, but that was the extent of the legislation for fifteen years. On October 1, 1883, the city council passed Ordinance 66, which prohibited boys from being on city streets "after certain hours." A prohibition banning your livestock from "running at large" in the city was not enacted until September 1887. Both sides of the issue had a surprising number of followers. The final council vote was a tie, with the mayor voting

ELEGIES AND BYGONE PLACES

Robert Newell, circa 1868.

Catherine Yagen McGrane, circa 1870. *Courtesy of the Swinehart Archives.*

The graveyard fence, Masonic Cemetery, 1881.

aye. With no homes in the area of the cemetery, no one had seen any need to fence off his property; and when anyone wanted to do so, the city council had to give its permission. Cattle, goats, horses, mules and dogs roamed freely. The meeting that addressed roaming livestock also instituted licenses and metal tags for dogs, which were a constant problem as they were wont to scavenge for food among the open trash heaps of town and even in the cemetery. In September 1891, milk cows got an exemption "for certain hours morning and evening to be at large."

In an effort to make access to the cemetery somewhat easier, the committee on streets began working in October 1879, while Charles Thatcher was installing the fence, to determine how best to grade Fifth Street up the hill to the level of "City Cemetery Road," which was what is now Second Avenue. No hearse could make the Fifth Street climb, given the state of the "road." Cortèges used an old wagon road that predated the Prospect Avenue grade but topped out at Second Avenue. From there, it was a quarter of a mile to the cemetery. Ordinance 32 authorized the project on November 18, but funding was left to another "subscription list." Companies submitted bids on the Fifth Street project in December 1880, but the numbers that came in scared off the city fathers. The street remained an ongoing but unfruitful topic until the opening of the normal school. The first Sanborn map of

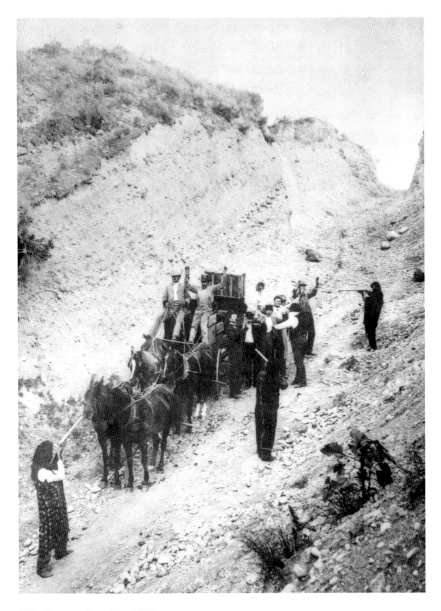

Fifth Street gulley, circa 1895.

the area in December 1900 shows scores of new homes. Unpaved and in need of regular grading and sprinkling, the street was finally surfaced with concrete in 1931, but by that time the old cemetery was an indistinct and confused memory.

In 1884, the Wallace W. Elliott Company published its *History of the Idaho Territory*, in which it sought to describe the "scenery, residences, farms, mines…houses, school, churches," as well as tell the story of the twenty-year-old territory. Among its comments about the appearance of Lewiston, the volume relates:

> *The summit of the plateau is just above the chimneys and nearly horizontal, and the white fences of the burying grounds on the top, in the distance, add to the delusion of a constructed parapet.*

Any attempt to recreate the exact layout of graves in the old cemetery is purely speculative and based on second-hand evidence. No one went around with his camera taking pictures of the grounds. Indeed, only one photograph exists showing an actual grave site, and in it we can see Thatcher's fencing along the north edge of the grounds. However, we still know a few important things the cemetery. By 1881, there were three sections to the cemetery parcel: city, Jewish and Masonic. The city section took in the south end of what is now Pioneer Park, extended at least two hundred feet north from Third Avenue and stretched from the old Idaho Supreme Court Building to beyond where the road now leaves the park at its southeast corner. This is not to say that there were no grave sites where that building is still located, but no headstones appear in panoramic photographs of the city.

However, not all graves had markers. Normal Hill Cemetery has fewer than 130 headstones dating from 1867 to 1888 that were moved after the old graveyard was closed to further burials in January 1889 and subsequent to the order for final exhumations in July 1893. With a graves registry that might well exceed 400 when it is completed, we could be seeing the paupers' or county burial area of the city section. When the Supreme Court Library was constructed in 1904, no one reported the discovery of old graves. However, when a new south wing of the Carnegie Library was set for construction in November 1950, project architect William Parr warned workers to be alert for "an old burial ground." The Masonic Cemetery was found on the brow of the hill at the far north end of the cemetery.

The Jewish Cemetery's exact location has been long debated. Once thought to have been adjacent to the east of the city section, the analysis of images from the 1880s seem to indicate that the Jewish burials were located where the park restrooms and grounds-keeping storage building are now found. Described in April 1889 as being "in bad repair," the cemetery gates were found at the intersection of Fifth Street and Second Avenue, where

the entrance to Pioneer Park is now located, and the terminus of "City Cemetery Road."

Graveyards are intended to be permanent, inviolate resting places deserving of community care. They are the local time capsules of lives like our own. An in-depth study of a cemetery is a reconstruction not of mute buildings or streets, but of breathing people who lived days similar to this one, as you sit quietly reading this chapter. When a cemetery's history is recreated, whether by traditional research methods or the latest technologies, we relive long-lost realities, resurrecting and imprinting memories on new generations, usually completely unconnected to those buried in its grounds.

Cemeteries are the sorts of primary sources historians so avidly seek, offering insights into the social structure, politics, religious commitment and relative wealth of communities. A cemetery's marker placement, prevalence of religious headstones, diversity of fraternal organizations and size and condition all provide clues about the past. Many pioneer cemeteries have fallen into disrepair, disappeared into the landscape as markers disintegrated or have been moved to new locations. As Idaho's pioneer communities matured, their original cemeteries reached capacity; towns were forced to expand or relocate their original cemeteries. In a very real sense, the opening of new and funded cemeteries signaled the coming-of-age of many frontier communities. Lewiston was no different.

By the late 1880s, Lewiston's cemetery had outlived its usefulness. The town had filled its original foothold along the Snake and Clearwater Rivers, the spring floods of which repeatedly destroyed property and hindered business growth. The city was using only a fraction of its one-square-mile dimensions, and the location of the cemetery posed a roadblock to future residential development. The solution community leaders ultimately chose—to create a new cemetery and abandon the old—and their clumsy implementation created a century of rumors about fraudulent reburials, misplaced grave markers and a scattering of skeletal remains that have baffled park visitors.

On December 5, 1887, the city council moved that a committee be appointed to select a suitable place for a new cemetery. No action was taken. The city had been petitioned as early as January 13, 1887, to move the cemetery. In May, officials proposed that the cemetery be moved to east Lewiston. That proposal failed to gain support, but public sentiment had clearly shifted, and selecting a new site was a priority.

On March 14, 1888, the city purchased forty acres of land from William T. Cox, a local stockman and father of seven children still at home, for $700

($18,000). There was, however, a bit of a snag. The property was located outside the city and, therefore, not subject to its codes and ordinances. As a result, the city council petitioned the territorial legislature on April 23, 1888, to allow the property to be annexed. Lewiston's city limits grew by eighty rods (1,320 feet), the distance from Eleventh Avenue to Fifteenth Avenue.

Remember: all the while, people were still dying and being buried in the old cemetery.

Local undertaker John Menomy and W.B. Cooper, a surveyor, busied themselves laying out the grounds (*Hidden History* 66). In September 1888, agreements were reached with the Masons, Odd Fellows and Knights of Pythias to provide for fraternal sections in the new cemetery. Five hundred feet of the south end of the new grounds were allocated to the lodges, to be held in common. Church records indicate that the Masonic Lodge continued to maintain its cemetery at the original site. Today, only the Masons still own their section of Normal Hill Cemetery.

On November 1, 1888, the *Lewiston Teller* announced "the new cemetery is now ready." Twenty-two-year-old Charles Wiggin, the son of one of Lewiston's more famous businessmen, died of spinal meningitis less than two weeks later and was buried in the Odd Fellows section on November 14, the cemetery's first interment. Less than a month later, Ordinance 100 was passed by the city council:

> *Sec. 1: It is hereby declared to be a misdemeanor for any one to bury any deceased person within the limits of the City of Lewiston as now defined by the provisions of the present charter of said city.*
>
> *Sec. 2: Any person or party violating the provisions of Sec. One, of this Ordinance, upon conviction before any court of competent jurisdiction, shall be fine in any sum not less than ten dollars ($260) nor more than fifty dollars ($1,300), together with costs of prosecution and ten dollars shall be allowed in each case and taxed as costs for attorney's fees, and all parties so convicted shall stand committed to the City jail until such fine and costs are paid.*

The old cemetery was only closed to new burials, and people had to quit burying relatives in their backyards. These "at home" burials were not uncommon. Workmen renovating a walkway and installing a pool several years ago at a Normal Hill home told me of the graves they unearthed. It is still not against the law to conduct a home burial in Idaho unless a local zoning ordinance expressly forbids the act.

The removal of remains from the Fifth Street site began in March 1889 with the exhumation of Mida Sprenger and Dennis Bunnell from the Masonic section. From all indications, the Masons moved quickly to clear the area of their original graveyard. In April, Christ Weisgerber purchased the first plots in the Division One of the city section for $4 each ($100) and proceeded with the exhumation and reburial of four family members: Mienny, Henry, Isabella and Anna. That same month, the body of Henderson Crites was removed from the Masonic section to a new grave site with fellow lodge members. The Weisgerber reburials do give us a few tantalizing hints at the placement of graves in the old cemetery. Based on the current placement of their old headstones, the graves for family members in the original cemetery were probably excavated very close side-by-side, often no more than thirty-six inches apart, measured from the graves' centers. Burial plots today are forty-eight inches wide.

In the only extant image from the Fifth Street Cemetery, three markers can be seen aligned east to west. The two upright markers served the same grave, that for Evangeline Vollmer, who died on September 27, 1881. The upright plank on the right was the "footstone," which might have contained Evangeline's initials, as was a common practice. Cemetery etiquette once frowned on the walking over of graves. Acting like boundary markers, footstones gave no one any excuse. If footstones were common in the old cemetery, they are not found at Normal Hill, either by design or covered by ever-encroaching sod.

One more bit of evidence appears in the image. What appears to be a downed marker for another grave can be seen in the left-center portion of the photograph. If that is true, rows were no more than ten feet apart, compared to the sixteen feet in Normal Hill Cemetery. The old Masonic section, which held thirty to thirty-five graves, would have seemed cramped in some areas, not unlike many old churchyard cemeteries in the East. The new cemetery planners would change that.

The Vollmers did not publicize when they exhumed their daughter Evangeline from the grave in the photo and moved her body to the new Masonic section some twelve blocks away, but the event probably occurred in the spring of 1889, at which time the family added a new granite plinth to complement the original marble angel headstone placed at her grave in 1882. That marker augmentation makes appropriate a few comments about headstones moved from the old cemetery, as public safety can be an issue with those that have survived.

Aboveground markers today are always anchored to prevent their being knocked over, not by roaming livestock but by drunken young men. Anchoring was seldom the case in Lewiston before the new cemetery opened. In the photograph of the graveyard, the markers are obviously wooden. What we see above ground was matched by a length of the board below the soil. If the family obtained a marble or granite replacement, it was most often an upright engraved stele, or upright slab taller than it is wide, the bottom portion buried to a good depth to hold it in place. This was particularly the case with the government headstones provided to veterans, beginning with those from the Civil War, with the familiar shield shape behind the name.

Evangeline Vollmer, circa 1879. *Courtesy of the John P. Vollmer Family Archives.*

That plan did not always apply to monuments, obelisks, statuary and the prefabricated metal markers that were popular in the 1880s. These types were all too often just set on the ground, held in place by their sheer weight. Several of the headstones removed to Normal Hill Cemetery fall into this category and can be easily rocked back and forth on their bases. The earliest headstone known to have been carved in Lewiston dates from December 1891 and was created by R.F. Beale, a "marble and stone contractor" who owned a quarry near Juliaetta, Idaho, and who would later fashion much of the marble on the Montana capitol in Helena. Many of the old stones from the first cemetery bear the inscriptions of "Spokane Falls" and "Walla Walla."

The lesson: be very careful when cleaning or standing near headstones dating from before 1890. Do not lean on them. One never knows how well they have been secured.

John Menomy died in September 1889, and in December his daughter Ethel was exhumed and reburied next to her father. She was followed a year later by the reburials of her mother, Mary, and stepmother, Emma. At

this point, local newspapers go strangely silent concerning the old cemetery. That all changed in May 1893.

Mayor Charles Kress, who was twice Lewiston's postmaster, established a working committee "to devise ways and take the necessary steps" to remove the remains of those still buried at the old site. This initiative resulted in the passage of Ordinance 144:

> *Section One: All persons and parties who have buried and deceased persons in the old cemetery of the City of Lewiston are hereby required to remove the same to the New Cemetery of said city, on or before the fifteenth day of June, AD 1893 else the removals will be made by the City at the expense of those who caused the burials to be made.*

There are no records to indicate just how many families responded to the city's order by executing their own exhumations. It seems certain that the individuals who purchased new grave sites at the new cemetery in the spring of 1889 had long since taken care of what was now being portrayed as a civic duty. Gravediggers were unlikely to find family graves for Weisgerbers, Moxleys or Kettenbachs, the early buyers of lots in the new cemetery, but that is another story altogether (*Hidden History* 78–79).

For most communities, the ordinance might have been the end of matters, but not in Lewiston. All would have remained quiet had it not been for a survey ordered by the city in March 1895 in order to lay out the parcel in lots for future sale. That survey opened the proverbial can of earthworms. The May 6, 1895 minutes of the city council express it best:

> *It appearing to the satisfaction of the Council that certain persons were buried upon lands owned by the City, to-wit: deceased relatives of R. Grostein and A. Binnard, the Marshal is ordered to notify the interested persons to remove such bodies at once to the new Cemetery of the City.*

Jews take a much stronger position regarding disinterment than do Christians. By tradition, Jews require funerals to take place within twenty-four hours of death, with members of the community keeping vigil over the body until it goes in the ground. Opening graves is forbidden in most cases by Jewish law. According to the Orthodox interpretation, land even suspected of containing Jewish remains should remain untouched, so as to facilitate the resurrection of the dead. Exhumation is allowed only when a body is to be reburied with family or in Israel. Although the Grosteins

and Binnards were adherents of Reform Judaism, their reticence to exhume their family members was now very apparent and orthodox.

The reconstructed graves registry shows that at least five family members were buried in the old cemetery—three Binnards and two Grosteins. Jewish graves rarely lack markers. Gravediggers could not have missed them, as they had done in 1893, when twelve additional graves had been found during the reclamation of the old site. A Jewish marker or monument serves to identify the grave so that relatives will find it when they visit. It is not uncommon to see small stones atop the Jewish stones in Normal Hill cemetery. *The Encyclopedia Judaica* comments that Jewish tenets concerning resurrection were "taken so seriously that pious Jews are often concerned about the clothes they are buried in."

Had the city contractor for the exhumations in the summer of 1893 been bribed to look the other way? The Grosteins and Binnards had quarreled with the city on other issues, including local taxes. The families and the city eventually reached an agreement, in no small part because of the death and burial of Isaac Grostein in November 1896. The new cemetery finally had a family member next to which exhumed relatives could be reburied.

As a historian, I attempt to experience the past in as many ways as I can. It was only natural that I would want to observe an exhumation. When those additional twelve graves were found in the old cemetery in 1893, the newspaper reported "all of the bodies found could not be identified" and were reburied as "unknown." The lack of grave markers and no plot map hindered Dudley Gilman's rush to finish the job and exacerbated the resulting shoddiness of his efforts. What would be the case in a modern exhumation?

On July 21, 2003, I was granted permission to observe and assist with the exhumation of a woman who was buried in Normal Hill Cemetery in 1972. The major difference between burials today and more than a century ago is the use of a vault, which is intended to prevent the collapse of the coffin, as would happen within a few years of old burials. Without a vault, unsuspecting cemetery visitors would be as surprised as I was when a grave collapsed under me while on a fact-finding walk one Sunday evening, not in the old cemetery but in the current one. That grave-turned-pitfall dated from the 1920s, was unmarked and was obviously completed too economically.

Even with modern embalming, the remains we found in July 2003 were disarticulated and devoid of tissue. The poor design of the vault had allowed ground and irrigation water to enter, thoroughly decaying the undoubtedly expensive coffin her family had purchased for her. Only bones, a set of false teeth and scraps of fabric from her burial dress remained. The mortician

with whom I worked could confirm the identity of these remains. In most instances, Gilman did not. After as much as twenty-five years in the ground, without a vault, and in some instances, the crudest of coffins, the bodies of Lewiston's pioneers would have degraded into jumbles of soggy wood chips, a skull, a few larger bones and a maze of fingers, toes and vertebrae.

The most intriguing discoveries in Lewiston's old cemetery did not result from traditional historical research but from the utilization of modern technologies. Ground-penetrating radar (GPR) was first used in the 1920s to measure to depth of an alpine glacier, but its potential was only realized in 1958, when an American plane crashed on the Greenland ice sheet while trying to land using radar as an altimeter. Scientists realized that a radar beam passes through different media at different rates. Ice, soil and rock all supply differing feedback. By the 1980s, the petroleum industry had adapted GPR as a remote sensing tool to find oil pockets.

The city was adamant about not having a team of high school students digging in a public park for human remains that no one was absolutely certain were there. However, remote sensing, which does not disturb the soil, met with official approval. GPR works very simply. A radar generator is dragged along predetermined lines on the ground. A pulse beam is focused down through the soil. When the beam meets a layer with a new density, it bounces back to the receiver, which is housed in the same unit, and is processed into an image.

A ground-penetrating survey scan, Pioneer Park, 2004. *Courtesy of the Branting Archives.*

LOST LEWISTON, IDAHO

In October 2004, five suspected locations for remaining graves were scanned in the old city section of the cemetery in Pioneer Park. The results confirmed what anecdotal histories and my research had always asserted: many graves remained from the old burial grounds. One scan (shown on the previous page) proved especially enlightening. Several narrow, highly reflective formations were detected in the lower left of the scan image and at eleven and thirteen meters. While the formations varied in length, they were all one to two meters in length and oriented east to west. Based on the data, the features are believed to be artificial and would suggest a set of graves.

Remember those headstones that were moved to Normal Hill Cemetery? When GPR scans were conducted at those grave sites, a full 50 percent showed no evidence of the soil having been disturbed. In short, they had moved the headstones all right, but not the bodies, which was not all that uncommon when frontier towns went about opening up new cemeteries and clearing the old ones.

Some information gathering requires you to get on your hands and knees. The ancient Greek word translated today as "to peer" originally meant "to stoop beside." My field assistants and I stretched out on the ground and used wire probes to investigate the top layer of soil below the grass line. Working directly above the sites located with radar, a student located a piece of bone within the first thirty minutes of the ground survey. Not being an anatomist, I submitted the remnant to Washington State University for identification. The verdict was conclusive: a piece of human metatarsal from the right foot. When the bones of the feet and hands fall free from a skeleton, they slowly drift to the surface in a process called percolation, as they are less dense that the surrounding soils. A longtime friend had told me that he had found small, mysterious pieces of bone while checking for coins in the park with his metal detector decades before. Our find affirmed his long-held suspicion.

Wishing to make one final effort to discover what lay below the grass of the park, we extracted core soil samples in June 2008 at key locations, again tied to where GPR detected possible graves. The focus of the study was to see if any arsenic remained from bodies embalmed in the late nineteenth century. Groundwater contamination was a real possibility. One soil core contained a small number of silvered flakes that showed evidence of wood fiber on one side. Vaporizing the samples and reading their chemical signature produced two important, albeit not unexpected, discoveries: the arsenic level was 30 percent higher than normal for the soils, and we had punctured a zinc-lined coffin. These containers became fashionable during the Civil War, when the long-awaited arrival of a corpse from the battlefield proved to be singularly unpleasant without a sealed coffin. In warm weather,

the coffin could be filled with ice to preserve the body before burial. How can one not be reminded of Carl Sandburg's poem "Grass" (1918)?

> *Pile the bodies high at Austerlitz and Waterloo.*
> *Shovel them under and let me work—*
> *I am the grass; I cover all.*
>
> *And pile them high at Gettysburg*
> *And pile them high at Ypres and Verdun.*
> *Shovel them under and let me work.*
> *Two years, ten years, and passengers ask the conductor:*
> *What place is this?*
> *Where are we now?*
>
> *I am the grass.*
> *Let me work.*

 The cemetery assumed its present identity in June 1899, when the grounds were set aside as the Fifth Street Park, after several offers were rejected to use it as the site for new construction for private projects (*Historic Firsts* 102–03). Those plans were certainly complicated by the fact that many people knew that the grounds contained many graves. Construction did occur, but only after the grounds were heavily contoured in December 1893, when Dudley Gilman plowed and harrowed the parcel. These landscaping efforts were only discovered when the playground equipment, installed during the 1990 Idaho statehood centennial, was removed in December 2004.

 As the old equipment was pulled up, the soil layers could be easily examined in detail for any evidence of disturbances. Surprisingly, the soils were quite void of natural strata, a clear sign of the extensive use of fill dirt. The park developers radically groomed the south end of the park, the area once taken up by the city section of the old cemetery. After a comparison of the park's present topography with historical photographs, it became clear that the area of the old city cemetery section had been "buried" under fill of at least a yard. The south end of the park is appreciably higher than it was in the 1880s. The graves that still exist under the playground are now much deeper than "six feet under." The fill materials for the southern portion of the park most likely came from excavations in other areas of the park, which are measurably depressed in comparison with what is shown photographs taken before 1910.

As the decades passed, the old cemetery continued to make its presence known, even as residential neighborhoods grew up around it and children played in the park above it. Reputable sources relate that, during the 1950s, a skull was dislodged from the hillside on the north end of the park. Some investigators, including Lewiston police officials, felt the discovery was the remnant of an unfortunate miner who had died while trying to excavate the area. They had also uncovered iron rails in the embankment. Were they the last traces of an old, collapsed mine? The truth was a lot simpler.

In February 1881, the city approached John Vollmer to find out if 1,600 feet of iron rails could be obtained to stabilize the hillsides along the Fifth Street grade leading to the old cemetery. The skull was most certainly an artifact from the Masonic graveyard and substantiation that not all graves had been relocated during the exhumation process more than a half-century before. Unfortunately, the skull has long since disappeared. Alas, poor Yorick!

The neglect heaped on the old cemetery when it was an active site would not be repeated in the new graveyard. In March 1889, a cemetery fund was created. Over the next four years, a proper and dependable well was dug, and pumps were installed to properly irrigate the graveyard. A standing committee was created on the city council for the cemetery. Statutes were enacted "to prevent trespass upon grounds outside of avenues and alleys, and fixing penalties." The new cemetery would have its own road system, for which there is no evidence at the Fifth Street site.

All of the principals to this historical mystery have long since died, giving us only limited opportunities to rebuild from firsthand accounts the stories of bereaved families laying family members in their graves. Regrettably, all the stories we would like to hear about the lives of so many Lewiston residents may forever elude us. However, after ten years of intensive study, using both traditional research and digital technology, Pioneer Park's stature is assured, not as an abandoned or vacant Lewiston cemetery. These are hallowed grounds that deserve the full measure of their heritage and our continued respect. How unfortunate it is that we took nearly 120 years to discover the truth.

In the end, the words of Walt Whitman, in his "Pensive on Her Dead Gazing" (1865), echo in my mind as the "Mother of All" pleads with the earth to safeguard her children:

> *Exhale me them centuries hence—breathe me their breath—let not an atom be lost;*
> *O years and graves! O air and soil! O my dead, an aroma sweet!*
> *Exhale them perennial, sweet death, years, centuries hence.*

7
TALES FROM THE OUTSKIRTS OF TOWN

Lewiston has long been a nexus for Idaho's educational system. The city was the site of the first school district to be chartered by the territorial legislature (1880), the territory's first college (1882) and the state's first junior high school (1914).

When the bill creating the State of Idaho was enacted in 1890, one of its provisions required the establishment of a "normal school." Reaching that point in the development of the state's school heritage took thirty years. Before telling you some of the tales of old Lewiston State Normal School and its subsequent incarnations, let's trace the path that Idaho's schools took before the legislature created the college in 1893.

When the territory was formed in March 1863, the organization of local schools was left up to the individual communities, which had their own rules for checking how competent a prospective teacher was. School boards, some of which had members who were rumored to be illiterate, were directed to consult with the county auditor, who was, because he maintained county records, the *ex officio* superintendent of schools (*Hidden History* 28).

By 1871, the territorial legislature realized that more scrutiny was needed and began to offer assistance, recommending that new teachers should by examination "show proficiency in spelling, writing, arithmetic, geography, grammar and a capacity for impartial instruction." However, the buck still stopped with the local districts, which were not always amenable to government control.

By 1875, the legislature had given the territorial superintendent of schools the authority to make "suggestions" on what the examinations should include. In 1880, county superintendents took over the role of examiner of prospective teachers. Three types of certificates were awarded. Candidates with the highest marks on the examination received a "first grade" certificate. The next echelon got "second grade" permits. Those who rattled the bar by barely meeting the basic requirements were handed a "third grade" license to teach. It was very apparent by 1882 that many districts were ignoring the regulations. The legislature promptly made it illegal to pay a teacher who was not properly certified, and it is at this point on Idaho's timeline that the word "normal" first appears.

In May 1882, James Gardiner arrived in Lewiston to become head of Independent School District 1 and had an immediate impact on the territory's control over teacher education (*Historic Firsts* 71–72; *Hidden History* 29). That summer, Gardiner announced a schedule for teachers' institutes, in conjunction with the Lewis Collegiate Institute, to provide "normal training" (*Historic Firsts* 77–78). Indeed, the publication *Executive Documents of the 49th Congress* (1886) lists Lewiston as the only site in the territory for such instruction, which was made mandatory for all teachers in 1883.

So, by 1893, Idaho's educational system of certifying teachers had gone through eight revisions and thirteen law changes. Readers of Lewiston's newspapers had grown accustomed to reading the following notice:

> *Teachers employed by the public school board will stand for an examination this week before beginning their labors.*

Thus it was that, when the state legislature met in January 1893, the time seemed right to create the "normal school" prescribed in the statehood bill.

At this stage of our story, a discussion would be in order to explain the concept of a "normal school," a concept that began with the founding of the *École normale supérieure*, in 1793, to provide the French Republic with a body of teachers fully trained in the latest teaching techniques. The word *normale* (or normal) was a reference to the standards used to train students to teach and the standards of practice for the classroom. The first American normal school opened in 1839 and is now Framingham State University, in Framingham, Massachusetts. For more than a century, American normal schools usually trained only primary school teachers.

In 1893, Idaho did have a functioning university in Moscow, and that very fact almost scuttled Lewiston being chosen as the site for a teachers'

college. Few people realize that the university's place in Idaho's educational hierarchy is safeguarded by its inclusion in the state constitution. The founders of the university remembered all too well what happened during the territorial legislature of 1864–65: the capital had been moved to Boise City, in an action still debated by scholars over its legality.

When it came time to choose a site for the normal school, legislators began to wonder why they should put it just thirty miles from the university in north Idaho, a region that had long and loudly lobbied to be annexed by Washington. Former North Carolina congressman and Lewiston lawyer James Reid had been a member of the 1889 Constitutional Convention and was a savvy judge of the political winds. He offered his fellow legislators and the governor a deal: he would help quell the annexationist fervor in Lewiston and deliver the north in support of the new state constitution in return for the normal school.

Much to the chagrin of people in south Idaho, who were still smarting from the placement of the university in Moscow, Governor William McConnell signed the legislation to place the school in Lewiston in January 1893. Southern legislators threw a great big hissy fit, and within weeks, a political compromise was reached to open a second normal school in the small town of Albion, near Burley.

It is one thing to create a new college—in this case, Lewiston State Normal School—and quite another to build and maintain it. The bill McConnell signed had only Lewiston's donation of ten acres of land amidst sand dunes and sage brush to back it up. Reid was named to the first board of trustees and was later elected its president, serving until his death on January 1, 1902. So cash-strapped was the new college that Reid funded the stationery for Lewiston State Normal School's board of trustees out of his own pocket. The first school president, George Knepper, did not even arrive until November 1895 and found that he had no building in which to hold classes.

Knepper was not one to wait for legislators and contractors to make up their minds. He approached Robert Grostein and Abraham Binnard to rent the second floor of the opera house that the longtime Lewiston entrepreneurs maintained on the corner of Second and Main Streets (*Historic Firsts* 73). Classes commenced on January 6, 1896, with forty-six students attending. Blankets were used to divide off classrooms at the theater. As north Idaho had less than five high schools at the time, Knepper and his staff welcomed students as young as fifteen (for girls) and sixteen (for boys). Until 1897, the minimum age to teach in Idaho was sixteen, and that limitation was not in place until 1893. The curriculum at Lewiston State Normal School was, as

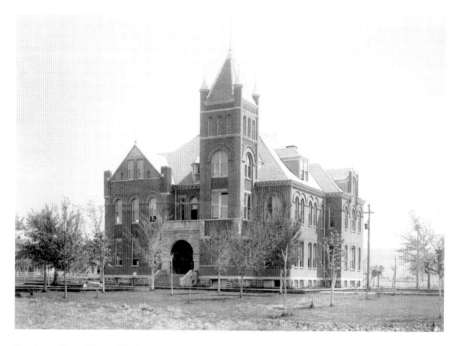

Lewiston State Normal School, circa 1901.

with other such schools, only two years in length, and Idaho did not legally require that much training until 1913.

"Student life seems incomplete without some means of communication with the outside world." That is how the editors of the *Normal Quarterly* opened their first issue in December 1897. President Knepper had created three literary societies: the Normal Society, the Clionians and the Excelsiors. All of the students belonged to the Normal Society and then had to choose between the other two, which were in friendly competition for members and the quality of their campus activities. That first issue of the *Quarterly* praised the achievements of the "tennis club," which was the Normal's first athletic team. The tennis courts were located behind what is now Reid Centennial Hall. Several Lewiston players, including Katherine Fix, were state and regional champions. The student editors bemoaned the lack of baseball and football teams. Both sports would eventually be sanctioned. Baseball remains, but the college has not sponsored a football team since 1950.

With growing enrollments, Knepper perceived a pressing concern. The campus was isolated on the outskirts of town and had no housing for students. The reader may find it interesting that the original city limits to the south were at what is now Eleventh Avenue. Harris Field, the site of so many

ELEGIES AND BYGONE PLACES

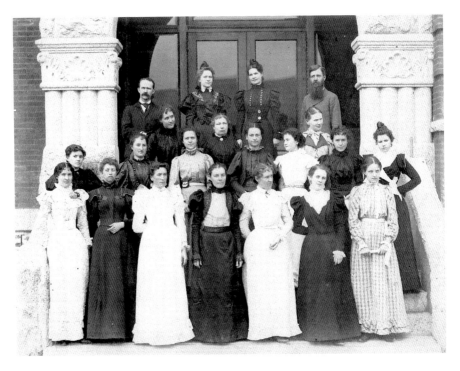

The first graduating class, June 1898. *Courtesy of Lewis-Clark State College.*

National Association of Intercollegiate Athletics baseball world series, sits on the very edge of the original city. Normal Hill had few homes where students could board. When the normal school graduated its first class in June 1898, most of those students had been forced to walk from lodgings downtown, up an unpaved Fifth Street grade, down muddy streets lacking sidewalks and through wheat fields to get to their classes. In August, Knepper's requests for lodgings were appearing in the local newspapers. The rural nature of Normal Hill was emphasized in April 1900, when the city council granted several landowners permission to temporarily close streets and alleys so that the properties could be fenced in and seeded to rye, in an effort to prevent the drifting of sand.

Knepper pressed the issue and received funding to erect two dormitories, Idaho's first. Referred to as "inmates" in newspaper reports, the men stayed in Reid Hall, the women in Morris Hall, which was named for Benjamin F. Morris, a member for the board of trustees. Morris Hall witnessed the founding of Idaho's first YWCA, in what new research shows to be 1899 (*Historic Firsts* 104–06).

The dormitories would never satisfy building codes today, had no indoor plumbing and needed community support to outfit the rooms. By September 1904, the women's dormitory was too small to handle the increased enrollment. A newspaper reported "many rooms have been engaged on the outside for the girl students, who are crowded out of the dormitory." By 1907, the buildings were totally inadequate, even by the standards of the time. Reid Hall was sold to a local contractor, sawn apart and moved off-campus to become two homes. In the meantime, Morris Hall burned to the ground. The school's new president, George Black, realized that parents would not send their daughters to school in Lewiston without

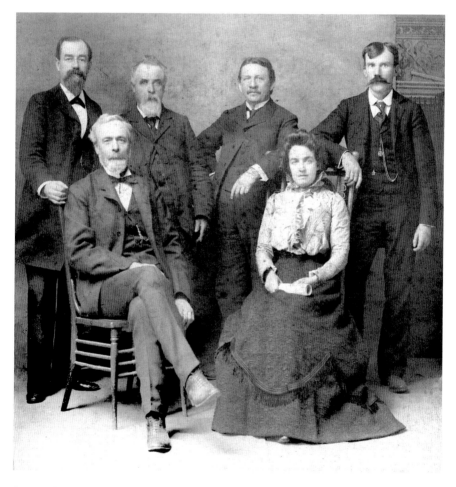

Board of Trustees, 1900. *Left to right*: James Reid, Benjamin Morris, James Poe, John Vollmer, Nellie Stainton Leeper, George Erb. *Courtesy of Lewis-Clark State College.*

safe and secure housing. As a result, Lewis Hall arose on Fifth Street, where Meriwether Lewis Hall now stands (*Hidden History* 14). A second women's dorm, Spalding Hall, opened in 1924. The men would not again have a dormitory until 1930, when Talkington Hall was opened, allowing the men to occupy Spalding Hall.

Although a small, detached laboratory (or training) school had been in operation by 1901, Black fought for and received funding to expand the administration building, which stood alone as a landmark on Normal Hill until 1898, when Visitation Academy opened, where All-Saints Catholic School is now found (*Hidden History* 21, 105). The tower to the college administration building was the focal point on Normal Hill and was the site of an April Fools' joke in 1904.

Lewiston State Normal School students liked to play yearly pranks on unsuspecting underclassmen. It was supposed to be "class day" for the juniors. As they were hoisting their flag above the administration building, the seniors locked them in and held them "captive." When noon arrived, an attempt was made to smuggle food to the besieged juniors. In the resulting food fight, "cups and saucers, corn beef and cabbage, baked beans and apple pie became intimately mingled, and the floor of the halls and stair steps received all the provisions." The juniors were released at the end of the day. There was no printable comment from the janitor.

On May 30, the high jinks reappeared when twelve Lewiston State Normal School boys were arrested for attacking fellow students who were enjoying a hayride. They overdid a practical joke by rubbing limburger cheese on the clothes of the girls and boys in the gathering. The judge delivered "a severe rebuke." According a newspaper report, "the defendants appeared repentant and crestfallen, and left the courtroom quietly, promising not to do it again."

George Black was an administrator to be reckoned with. In 1903, he had fired the entire faculty except for Henry Talkington. A new east wing was added in 1905–06 to the administration building to house new classrooms and the laboratory school and came at an opportune time. In 1909, Lewiston State Normal School was the first college or university in the Pacific Northwest to offer a specialized curriculum for teaching in rural schools. Fully 95 percent of all Idaho students were attending rural schools.

The new teacher training facilities were a model of efficiency. Professors' offices were located next to the training classrooms filled with local children who were chosen from a pool of candidates. On more than one occasion, administrators reminded parents that enrollment was an impartial decision.

LOST LEWISTON, IDAHO

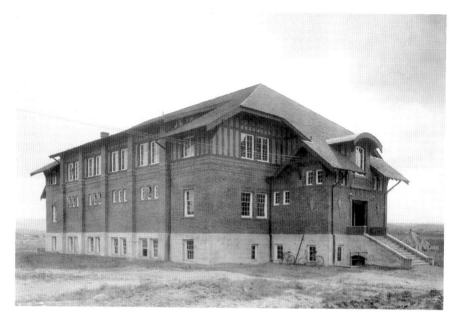

Lewiston State Normal School gymnasium, 1909.

Large windows had been installed between the classrooms and offices. A professor could observe classroom lessons at all times, even being able to call a cadet teacher in for direction while still ensuring that the students were constantly supervised. You know what little kids can be like when the teacher leaves the room. By 1909, enrollment at the laboratory school had reached two hundred children in grades one through eight. Student teachers were also assigned to train at several Lewiston-area public rural schools, notably the old Weaskus and Hatwai Schools in north Lewiston.

Opened in 1910, the Domestic Sciences building (now Jefferson Hall) housed laboratories for the study of bacteriology and food analysis and was, for many years, the center for science instruction and the first home for the Division of Nursing. Until 1951, the building also provided classroom instruction in the sciences for nursing students training at Saint Joseph's Hospital, located only three blocks from campus.

Black left Lewiston State Normal School in 1915, disillusioned with the poor support he received from the state level. In 1913, the school had lost its local board of trustees and came under the control of the state board of regents, whose history is replete with less-than-impartial treatment for its member institutions. Black's successor, Oliver Elliott, was a leader cut from a different cloth and struggled to make his mark on the college.

An architect's plan for a new campus after the fire of 1917. *Courtesy of Lewis-Clark State College.*

By 1917, the need for additional classroom space necessitated the construction of a west wing to the old administration building. Before it could be completed, the east wing was razed by fire on December 5, destroying the library and college records (*Hidden History* 121–22). Those beautiful training classrooms also went up in smoke. The Idaho legislature responded with uncharacteristic speed and funded the construction of the current administration building, which opened in 1922. Schools throughout the region helped rebuild the ten-thousand-volume library.

The school's public reputation received a well-deserved burnishing in 1920, when Idaho placed its office of educational testing and measurement on the campus, the first such center in the western United States. Under the leadership of Charles Harlan, the staff coordinated public school assessment statewide (*Historic Firsts* 135–136). It is of some interest that 1921 was the last year that the school awarded high school diplomas. When I was a young man, people still called the college "Tiger Tech," and no one meant it as a compliment.

By 1924, it was clear that President Elliott's health was failing. A diagnosis of cancer led to treatments that seemed to work for a time, but by December of that year, he was gravely ill. He died in Spokane, the school's only leader to die in office. The next two presidents shared much in terms of style and temperament. Both John Turner (1924–41) and Glenn Todd (1941–51) were former school district superintendents. Turner had been hurriedly recruited from Payette, Idaho. Todd would move just five blocks from his office at Lewiston High School.

Henry Talkington characterized Turner as a "no nonsense" and practical president. Keeping the college open during the Great Depression was no easy task. Many prospective students could not afford the costs, and the legislature had tightened its purse strings. As noted above, two new dormitories were added in 1924 and 1930. The old 1909 gymnasium was replaced in 1938.

When Glenn Todd became college president in 1941, it was clearly evident that the school was going to take a different path. Todd started offering night classes that year to accommodate Lewiston's large pool of blue-collar workers. In 1942, the American Association of State Teachers' Colleges accredited the school, making it one of only four two-year school in the country to be certified. Todd's greatest accomplishment occurred in 1943. The state board authorized the granting of four-year bachelor of arts degrees. In 1945, the college began certifying high school teachers, and 1946 saw the establishment of an accredited, five-week summer outdoor education program, which was

ELEGIES AND BYGONE PLACES

George Black (left), circa 1914. *Courtesy of Lewis-Clark State College.* Glenn Todd (right), circa 1940. *Courtesy of the Lewiston High School Archives.*

operated on land donated by Potlatch Forest Incorporated between Waha and Soldiers Meadow, twenty-five miles southeast of the Lewiston campus. Todd was, as people say, "on a roll."

When the normal school became a four-year school in 1943, Todd changed his letterhead. He had always disliked the word "normal," contending that it no longer adequately described the school's mission. For four years, he sent out official correspondence using stationery saying "Northern Idaho College of Education." In fact, the name was not approved until 1947. The end of World War II brought dramatic changes to Idaho as the national economy struggled to find a new equilibrium. Todd's accomplishments were soon forgotten as voices became louder and louder to close the teacher colleges. Critics contended that there was too much duplication of effort and asked, "Why have a major university if it could not supply Idaho with teachers?" Todd and the faculty soldiered on, but the other shoe soon dropped. A new governor was about to deliver on a campaign promise.

In 1951, a new men's dormitory, Clark Hall, was built adjacent to Spalding Hall and was ready for occupancy in the fall of that year. New Idaho governor

Len B. Jordan, circa 1946.

Len B. Jordan had other plans. Acting on his recommendation, the Idaho legislature cut funding to the college and left Clark Hall a white elephant in the eyes of the community. For the second time in the history of the school, the college faculty members had lost their jobs. An effigy of Jordan appeared at Lewis Hall on March 11, 1951 (*Hidden History* 14). The legislature's refusal to appropriate money for the operation of the college produced what were called "Jordan's orphans." The effigy disappeared on April 1. Another April Fools' joke? An interesting consequence of the closure was the waiving of eligibility rules for the student athletes who were forced to transfer to other schools.

On August 11, 1951, Northern Idaho College of Education held its last commencement exercises after fifty-eight years in operation. The next day, thirteen buildings were idled. A skeleton maintenance staff oversaw the campus until May 26, 1955, when Governor Robert Smylie signed the bill reopening the college, albeit as a two-year branch of the University of Idaho—Lewis-Clark Normal School. Closure of the college had been a disastrous experiment in cost cutting. The university failed to deliver on its promise of supplying new teachers. The shortage in Idaho had reached epidemic proportions in the intervening years. The college at Albion enjoyed no similar resurrection.

Its two-year status certainly gave the school a renewed foothold but forced graduates to transfer to the University of Idaho or some other four-year school, as Idaho's new teacher certification standards had also changed in 1955, requiring a baccalaureate degree. The days of the lifetime teaching certificate had ended. The college did not even have a president. From 1955 to 1963, two University of Idaho deans served as administrators for the college.

Effigies reappeared on campus in November 1959. Ruby Bouton, the popular school nurse, announced she was resigning, citing "a lack of support

from the dean and faculty members" over the work she was doing. Bouton was the former head of the polio ward at Saint Joseph's Hospital. Jay Karr, Wayne Sims and Glen Smith were the targets of the effigies after students learned the three instructors had questioned Bouton about reports she had submitted. It seems the rate of illness was high, and class attendance numbers were low. Someone must have forgotten that influenza plagued the school for weeks in the fall of 1957.

Dean Cleon Caldwell submitted a letter of support, signed by 142 students, along with Bouton's side of the story, to University of Idaho president D.R. Theophilus. Caldwell was overseeing the school's operations at the time. Sims became president of the college in 1963. Bouton shook the dust from her feet, went on to head the county mental health association and would appear on the popular ABC television show *Queen for a Day* in June 1962.

One of the least-known stories about the college occurred in early 1963. Cascade Christian College (Portland, Oregon), with the encouragement of some members of the Idaho Board of Education, proposed to take over ownership and operation of the campus. A visitation team arrived in secrecy to assess the buildings and property. On Friday, January 4, Robert Jones, one of my history professors, blew their cover. He just happened to pick up his paycheck as the team was standing outside the administration building. When Jones' request for information was rebuffed, he contacted Ed Williams, Lewiston's state legislator, and together they broke into a clandestine meeting in the old student union building (the converted 1909 gymnasium), demanding to know what was afoot.

Williams explained that neither the state legislature nor the State Board of Education had the power to transfer Lewis-Clark Normal School to private status. The reason lay in a 1907 city ordinance that had allowed the campus to expand toward Fourth Street. Remember that original land grant in 1893? Well, it came back to save the school. If Idaho transferred or even attempted to transfer the property, the land would revert back to the city. The school was saved. The same cannot be said for Cascade. The college closed in June 1969, and its student body was merged with Seattle Pacific.

In 1965, the college achieved its former independent status and was once again empowered to award four-year degrees. Construction on the campus resumed in the late 1960s, with the building of the Sam Glenn Complex as part of the campaign to consolidate the vocational programs, which were theretofore scattered around the city.

Just when you thought April 1 could not get any more interesting, along came 1970. In a stunning upset to those who attended (including this author),

the Lewis-Clark Normal School (LCNS) Warriors defeated the Washington State University (WSU) Cougars 5–4 in a late afternoon baseball game that was called because night fell. Harris Field had no bleachers, lights or outfield fence at the time. WSU came into the contest with a record of 10-0-1. LCNS was 5-4. Warrior pitcher Randy Wells held the Cougars to only three hits. The victory was a harbinger of things to come. Since 1984, the Warriors have won sixteen national championships, and WSU no longer wants to play at Harris Field.

After being known as Lewiston State Normal School, Northern Idaho College of Education and Lewis-Clark Normal School, the institution shed its teacher college image, in 1971, to become Lewis-Clark State College, but that is another story. For a detailed history of the college during its first one hundred years, I recommend Keith Petersen's *Educating the American West*.

The thriving, expanding community had surrounded what was once a small cluster of buildings located on the outskirts of town. Once an outlier, it had become an anchor for a dynamic city.

> Free home mail delivery began in Lewiston on June 1, 1903. Orville Livensparger and George Sullivan left on their first rounds at 9:30 a.m., with their second trip starting at 5:00 p.m. Carrier service extended as far east as Fourteenth Street, and a substitute carrier, C.W. Grinsted, soon arrived in the city. Postmen did not leave the mail if you were not home. Mailboxes were not required in the United States until March 1923. If a recipient did not answer a knock on the door, the doorbell or the mailman's whistle, he would return the letters to his bag, a process that could waste upward of an hour of his time each day waiting for people to come to the door (*Historic Firsts* 24–26).

8
IF THE GLOVE DOESN'T FIT

The murder of John "Buena" Siers on Sunday, May 19, 1895, at 21 Ranch, south of Lewiston, was briefly discussed in chapter four of *Hidden History*. Transcripts and photographs have surfaced that make the story worth an expanded retelling.

News of the deadly mêlée spread rapidly among the neighbors, and it reached Lewiston at a gallop soon after. The *Illustrated History of North Idaho* reported that "hundreds of neighbors and Lewiston people congregated at the scene of the terrible tragedy during the day…the most terrible tragedy that has shadowed the fair name of Nez Perce County since the days of Plummer's gang." By the time a Lewiston photographer arrived, Siers had been dead for hours. Someone turned him over and folded a large blanket into a pillow for his head. Authorities immediately took Mary Edna Goddard into custody, pending a coroner's inquest, which was held the next day and ordered her arrest for murder.

Goddard's trial at the county courthouse was a sensation, described as having "few parallels in the annals of crime in the State of Idaho" and being "one of the most bitterly fought murder trials in the history of Northern Idaho." Her attorney, Thomas C. Griffits of Spokane, was one of the best known in the State of Washington. He did not contest the claim that Goddard was "the sole cause of [Siers'] death." The testimony and coroner's report clearly showed that Siers had been ambushed and was defending himself when Goddard came up behind him and fired the fatal shots into his back. Even her brother Matt denounced the whole affair as a cold-blooded murder.

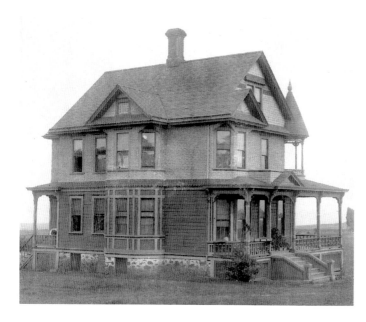

21 Ranch, circa 1900.

The neighbors, "in fact the majority of citizens," agreed. Griffits questioned what a reasonable person would do in Goddard's situation.

After forty days of testimony, the twelve-man jury deliberated for fifteen hours and returned its verdict at 10:45 a.m. on January 15, 1896. Before reading the verdict, judge William H. Claggett drew out his pocket watch and halted proceedings for one minute, in what can only be interpreted as his dissatisfaction with the words on the slip handed to him by the bailiff: "not guilty." None of the jurors were Lewiston residents. The *San Francisco Call* ran the headline "Great Surprise to All." *The Illustrated History of North Idaho* called the verdict an "indignant surprise." The trial cost the county nearly $13,000 ($360,000). Rumors spread that the jury had been bribed. Some claimed that Goddard's injuries swayed the jury. A bullet fired by one of Siers' defenders had shattered her wrist. Fellow defense attorney James Reid had, in what were called "eloquent appeals," convinced the jury that the glove did not fit.

Goddard promptly applied to have her attorney's fees and witness expenses paid for by the county. She returned to her life at the ranch with her daughter Edna, whose husband, Frank Ward, had started the altercation by shooting at Siers as he entered the barn to visit Matt, who was living in the outbuilding after a falling out with his sister. Ward died when Elmer Shorthill, a member of Siers' party, returned fire. Shorthill was charged with assault and intent to kill, but "at a *fair* trial he was completely exonerated and acquitted" [italics added].

John Siers' body at the crime scene.

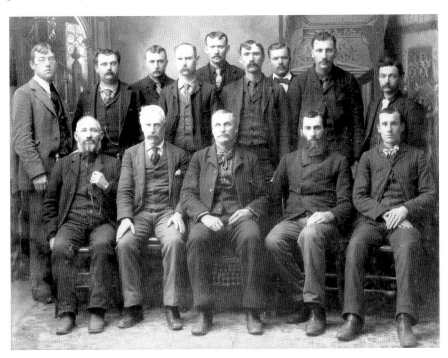

Goddard trial jury.

Defense attorneys Griffits and Reid both died in 1902. Edna married James B. McGrane in January 1903. They ran the Bollinger Hotel and Raymond House in Lewiston, while she served in the leadership of the Daughters of the American Revolution (*Hidden History* 40, 104). When Edna died in June 1954, her obituary made no mention of the infamous events of nearly sixty years before.

> James C. Taylor (aliases Franklin Brown, Charles Scott, Thomas Benton, James Field and Colonel G.W. Taylor) made bigamy a business. On March 31, 1892, he found himself under arrest in New York and assailed by claims from nine women who claimed to be his wife. He had regaled them all with stories of how he had lost his right arm to Indians on the plains or from heroic deeds in the Civil War. Taylor passed himself off as a wealthy ranch owner from Lewiston and took advantage of the relationships to bilk the women of their money. Sounds like a scam, right?
>
> He first surfaced in Los Angeles in 1888 and married a wealthy widow. Soon after the honeymoon, they disappeared. He "bobbed up" without his wife in the fall of 1891. An acquaintance asked what had become of his spouse:
>
> > *That was a bad bargain. I made a botch of that affair, a deuced botch. Why, my boy, do you know after I married her I found that all she had in the world was $15,000 ($400,000), a mere nothing. It cost me $75,000 ($1.9 million) to get rid of her.*
>
> Seeking greener pastures, Taylor moved to New York and began a brisk marriage campaign. He was finally arrested on charges of larceny brought by one wife from whom he had taken $1,000 ($26,000). His attorney protested that he could not be charged with stealing from his own wife. Taylor was willing to repay the money if she withdrew her charges. The district attorney agreed and then held him on charges of bigamy, for which he received a prison term.
>
> He was released in December 1894 and returned to his old ways. He was back in court in March 1895, after being arrested for stealing two travel trunks worth $300 ($8,000). We can only imagine what was in the trunks. He pleaded guilty and got five years. He later related in prison that he did so "in the hope of avoiding publicity, tacitly admitting that more serious charges might be brought against him." Does any of this sound familiar, Dr. Phil?

9
CAST OFF THIS AIMLESS BURDEN OF MY HEART

German author Johann Wolfang von Goethe ignited a fashion craze in 1774, when he published *The Sorrows of Young Werther.* Thousands of impressionable young people began dressing in yellow trousers, blue jackets and open-necked shirts, seeking to emulate the title character in a case of seemingly harmless idolatry. However, an unforeseen consequence soon startled people and moved alarmed officials to action. Goethe used the novel to banish his own suicidal impulses and had the hero of the story shoot himself in the wake of a failed love affair. Reports began surfacing of young men using the same method to kill themselves. The book was banned in many locations.

Two hundred years later, researcher David Phillips coined the term "Werther effect," using it to describe copycat suicides. In one study, German researchers were able to demonstrate that in the months after the airing of a miniseries in which the lead character killed himself by lying across railroad tracks, the number of actual railroad suicides climbed significantly. The scene had been replayed at the beginning of each episode. A year later, the German television network decided to rebroadcast the miniseries and was warned of the possible consequences, only to ignore the cautions. The incidence of railroad suicides spiked again. The reader may well wonder, at this point, where the Lewiston connection is among these sad tales of self-deliverance. In late January 1899, a wealthy Lewiston teenager killed herself and became yet another statistic. The circumstances of that cold Saturday morning began to congeal several decades before.

John Clindining, 1890. *Courtesy of the City of Portland, Oregon Archives.*

Joel Martin, 1903. From *The Illustrated History of North Idaho.*

John Clindining was born in Saint Stephen, New Brunswick, in 1831. Traveling overland, he arrived in California in 1851 and settled in Crescent City. He set out for the Idaho gold fields in 1862 and remained in Elk City for five years, trading in the Idaho mines at Kootenai and Warren. Setting up his headquarters in Lewiston, he married Helen A. née Martin Havard in 1881. She was the daughter of Joel D. Martin, an Idaho pioneer who set foot in Lewiston on July 5, 1862, "flat broke," as he would tell people. Martin was a member of the party that retrieved the remains of Lloyd Magruder and his murdered companions in the spring of 1864 (*Hidden History* 54).

John and Helen's union was a classic May-December romance. He was a longtime bachelor already in his fifties. She was twenty-three and recently divorced. In May 1883, Helen gave birth to the couple's only child, a daughter—Medora, named for the romantic heroine of Lord Byron's 1814 poem "The Corsair." The couple soon needed the comfort of a new baby in the home. On July 3, 1883, Edith, Helen's ten-year-old daughter from her previous marriage, died of diphtheria. She had lost another child—Frankie,

a son who was only eight months old, when he died on July 25, 1879 (*Hidden History* 49–63).

John doted on his daughter, who was described as "the idol of her devoted and indulgent father." His love for children predated his marriage. On June 15, 1877, Nez Perce warriors killed William Osborne at his Salmon River ranch. His widow was left with three children, one of whom—Willie—was sent to the Camas Prairie to begin his education. As he had the means and no dependents, John grew attached to the boy, took steps to care for his schooling and upkeep and offered to adopt him. John had a good home for Willie. In November 1874, the home was important enough to be used as a polling place for the county's legislative elections. Osborne refused the offer and moved her family back to the Little Salmon valley. With the disappointment of these events still fresh in his mind, John relocated to Lewiston and soon met Helen.

Supplying the mines in the region earned Clindining a sizeable fortune, which he used to buy up properties in Lewiston's old business district. *McKenny's Pacific Coast Directory* (1883–84) lists the firm of Clindining and Dubuc as "wholesale butchers." On January 29, 1887, John was deeded three lots and two structures, one of which had been used as the first Idaho

The first territorial statehouse, circa 1889. The best evidence indicates that the Clindining family is standing in front of the building. From *River of No Return*.

territorial capitol from 1863 to 1865. John moved his family into the other structure, a spacious home at 46 Third Street that was surrounded on three sides by an enclosed sleeping porch shaded by towering Lombardy poplars. The Clindinings' marriage only lasted a decade, ending on May 26, 1891, with John's death after a long illness, when Medora was eight years old.

Known to his friends as "Clen," a reference to the original form of his family name (Clendenin), John had foreseen the necessity to provide for Medora and placed her in the guardianship of her uncle Warren P. Hunt and his wife, Olive, who was Helen's sister. In his will, John left Medora $25,000 ($650,000). By all reports, the Hunts were exemplary guardians. Their home was "a delightful residence, a fitting place for one of Idaho's bravest and best pioneers to spend the evening of his days." The Hunts needed a child's laughter in their home as well. Their first child, a son, had died when just nineteen days old in February 1872, and their daughter, Clara Irene, was a victim to diphtheria in 1883 at the age of nine.

On November 6, 1892, Helen remarried. Her new husband was Charles F. Leland, son of lately deceased local pioneer Alonzo Leland and partner with his father at the *Lewiston Teller*, the city's most influential newspaper from the 1870s to the mid-1890s. Charles became city sheriff after the sale of the publication and was Lewiston's first official fire chief. In June 1893, he began work as a general agent for a stage company, becoming the agent for the Northern Pacific Express Company in May 1894. His offices on the first floor of the Raymond Hotel were at Lewiston's crossroads.

The Lelands soon began a family of their own. They welcomed a new daughter, Evangeline, on January 11, 1895. A boy, Laurence Rodney, was born on December 14, 1896, but sadly died of cholera on October 26, 1897. Charles and Helen expressed their thanks for the local outpouring of condolences in the *Morning Tribune*, but little else was mentioned. Helen had already given birth to a second son, Felix.

Medora was a popular girl. On June 3, 1898, twenty-five young friends "surprised" her with a fifteenth birthday party at the family home. "A delightful evening was spent with games and other amusements." Two weeks later, she hosted a party for fifty of her companions. At the end of that summer, Medora prepared to leave Lewiston to enroll at Saint Helen's Hall, an Episcopal girls' academy founded in 1869 and lately moved into its imposing new campus in downtown Portland, Oregon. Lewiston's high school curriculum ended at the tenth grade at the time, and many young girls from wealthy families attended private finishing schools. Two of Medora's Lewiston friends—Melina Saux and Lola Timberlake—matriculated with her to Saint Helen's that fall.

Melina Saux, circa 1895.

Medora left for Portland with her mother and aunt on September 10. The boarding school experience would end in disaster.

When Medora returned to Lewiston in December for the Christmas holidays, she told her mother that she did not want to return to Saint Helen's, preferring to enroll at the Visitation Academy, the Catholic girls' school that was accepting students just two blocks from the family's Normal Hill home on Fifth Avenue (then called Newell). She had even purchased her textbooks.

The events of this story began a precipitous rush to their conclusion on Friday, January 20, 1899. Henry Tobin had only recently moved his family to

Lewiston and was renting a little cottage east of the old J.M. Harrington saw mill upstream at the base of Twenty-first Street. The Tobins' life had been a trail of tragedies. Engaged in the wholesale and retail liquor trade in Walla Walla, Henry had been ruined in the widespread panic that accompanied the economic collapse of 1893. When the Walla Walla Savings Bank closed its doors in December, Henry lost nearly $7,000 ($180,000). Distraught by the losses, Henry vainly attempted to kill James Edminston, the bank's president who had misappropriated funds and, because of powerful allies in Walla Walla and Seattle, was poised to evade justice.

The Tobins' son John, a bright and promising twenty-five-year-old, died suddenly, and the family was forced to sell their home to pay for expenses. Henry took $1,500 ($41,000) from the sale and headed off to the Klondike gold fields, only to suffer shipwreck and the loss of all his belongings, including the money. Reaching Lewiston with his family in late 1898, he found work tending bar at the Oregon Railroad and Navigation Company exchange.

Henry had retired for the evening when his ten-year-old son ran into the house, exclaiming, "Mama has drowned herself!" Raised by the alarm, four neighbors set about in a skiff and soon located Emma's body near the mill, about three hundred yards below the point where she entered the river. Henry had no explanation for her suicide, other than she had been brooding for some weeks over the family's misfortunes and may have wanted to take her son with her into the river. Her body was laid out on rough lumber at the mill, dressed all in black, "with water still dripping."

At the Leland home on Normal Hill, Medora most certainly read the lengthy account in the Saturday issue of the *Morning Tribune*, and a plan may have begun to develop.

Annie Moxley, the spinster sister to two of Lewiston's most influential residents, died on Thursday, January 26, 1899, at the age of fifty (*Hidden History* 129–30). Her funeral was scheduled for Saturday. The weather had been very mild all week. Saturday looked promising as well. Indeed it would be, just a degree shy of the all-time record. Medora's mother left the family home to prepare for the funeral services, instructing Medora to take baby Felix to her stepfather's office. She would meet Medora there.

About a half hour later, just before noon, Medora arrived as instructed, quickly telling Charles that she would return in a little while. She kissed the baby and went out, walking down Main Street, passing and greeting several friends and acquaintances. She turned north on Third Street, passed the old Clindining home, skirted the train depot and walked to the end of Second

ELEGIES AND BYGONE PLACES

Lewiston waterfront, 1899, two months after the recovery of Medora's body.

Street, across the railroad tracks. A sandy beach sloped away from town into the streambed, as the level of the Clearwater was near its winter low, forcing the river into a narrow channel and increasing its speed.

Julius Neumeyer, who was returning from the confluence, saw Medora standing on the banks beyond the railroad turntable. She threw off her cape and muff and wrung her hands as if in despair. Medora moved toward the water, hesitated, wrung her hands again and then flung herself into the river. Neumeyer ran to the beach and was within ten feet of her as she was carried along by the current. He reported that her head was at times out of the water and that he unsuccessfully urged her to swim toward the shore. He later testified the she repeatedly forced her head under water and seemed determined to resist any efforts to save her. Several men working farther downstream could not reach her.

When Medora reached the confluence, she submerged and did not resurface. Neumeyer noted that "she made no outcry." A boat was quickly commandeered, and searchers worked all afternoon, dragging the river as far as Dry Gulch, six miles below Clarkston. Dynamite was even used. The use of blasting powder was not uncommon. In July 1900, the Hoboken, New Jersey Board of Health used hundreds of pounds to retrieve the victims of the Bremen dock fire, which claimed as many as four hundred lives. Lewiston's efforts failed. Charles Leland and Warren Hunt posted newspaper notices offering a $500 ($14,000) reward for the recovery of her body. Days and then weeks passed.

Lewiston was a small city beset with raw emotional turmoil in early 1899. Ten days after her suicide, the town learned that three of its residents had been killed in the Philippines while fighting against insurrectionists. Major Edward McConville, Corporal Frank Caldwell and Private James Fraser died outside Manila on February 5. No one enjoyed greater respect in the community than McConville (*Historic Firsts* 101–102). The shock of combat deaths among its residents and the subsequent burials upstaged the search for Medora, but the reward did not go unclaimed.

The density of a human body is slightly greater than fresh water. As a result, when a drowning person becomes unconscious, he sinks regardless of the body fat content. A victim will reach the bottom of a body of water in spite of the depth, unless the corpse becomes entangled in some obstruction on the descent. As the body falls deeper, the pressure of the water will compress gases in the abdominal wall and chest cavities. The body thus displaces less water as it sinks and becomes less buoyant the farther down it goes, until it reaches the bottom.

Searchers usually will find victims relatively close to the drowning site. Such was the case with Emma Tobin, whose body washed ashore. However, the current carried Medora's body well downstream. Unless the body of water is very deep, a corpse will resurface and drift with the prevailing current before washing ashore or coming to rest in a back eddy. So it was with Medora's body.

At 10:00 a.m. on April 27, nearly three months to the day after her suicide, a man living in an area some thirty miles downstream discovered her body washed up on the shoreline. Her corpse must have only recently surfaced, as traffic along that stretch of river was steady throughout the winter and early spring. Cold water will retard re-flotation, and the Snake River's average

Warren Hunt (left), circa 1900. From *The Illustrated History of North Idaho*. Charles Leland, 1884 (right). From *Elliott's History of the Idaho Territory*.

temperature for January was a frigid thirty-seven degrees Fahrenheit (three degrees Celsius) in the years before slack water arrived behind the dams.

What would have been the condition of her body after nearly three months in the Snake River? As cold water delays the normal changes of decomposition, bodies may be surprisingly well-preserved even after long periods of immersion. Cold water also increases the process of adipocere, which is the transformation of the fatty layer beneath the skin into a soap-like material. There would be no open casket.

Leland and Hunt immediately set out for Wawawai (three miles upstream from the present-day Lower Granite Dam) after receiving the news at Almota, from which a man named Mr. Allen telephoned Leland after a ten-mile trip to the nearest telephone. Allen was paid his reward and thanked, along with George Humason, for the attention they had given Medora's remains, which were returned to town on the steamer *Lewiston* for services on Sunday, April 30, 1899. Reverend John D. McConkey, pastor of the Lelands' Episcopal congregation, faced a complication. Church protocols expressly prohibited a clergyman from reading the burial service for a victim of suicide.

To quote a line from the 1944 film *National Velvet*: "How can there be so many currents in such a little puddle?" What had caused a young girl, "in her purity and innocence, just budding into womanhood, with every comfort and happy surrounding in home and guardianship," to take her own life? Many speculated, but those who knew the real answer were not talking. One newspaper claimed that she was said "to have chafed under necessary constraint. She suffered temporary aberration from real or fancied trouble."

"Temporary aberrations" were popular triggers in the public's eye. Henry Tobin thought Emma had suffered one. Confidants knew differently. Medora took the time to write a final letter—"a very affectionate farewell"—to her mother, assuring her of her love and asking why the water was so cold. Her closest friends could give no reason for what was called "this rash act." No young man came up in conversation. Relations with her parents at home were pleasant. Even that final note offered no explanation. Some opined that she was still carrying the weight of her father's death and an increasing sense of isolation as her mother had additional children with her stepfather.

Maybe Medora was experiencing deep depression for the first time. In his book *The Enigma of Suicide*, George Colt explains: "Most adolescent depression is caused by a reaction to an event, a poor grade, the loss of a relationship, rather than a biochemical imbalance...Many adolescents who experience depression for the first time don't realize that it will not last forever." However, the wording of the final letter to her mother tells modern

observers that Medora's act was really not so rash. She had been quietly despairing for some time. Some individuals contemplating suicide hesitate, not settled on the method of self-destruction. Emma Tobin had unwittingly given Medora the method. Psychologists agree that few emotional reactions are more readily transmissible by example than suicide.

We are left with another, more troubling possibility—one that would have meant social ruin for a popular girl. Was she hiding a dark and painful secret from her time at Saint Helen's Hall? This was an act of desperation. Was she pregnant, fearful of telling her mother and unable to think of any other option, not knowing the way out? We have so many viewpoints without knowing what really happened.

The very public reports assigning her death to temporary insanity—"a young girl's mad act"—gave McConkey the loophole he needed, for in the eyes of the church, anyone who took his own life was out of his mind, and God alone was his judge. Just to be safe, the funeral was conducted at the Leland home. Medora was carried to her grave by six pallbearers at services attended by "a large number of friends." Lewiston was in no mood for a religious controversy.

The discovery and return of Medora's body gave her family some consolation and a measure of closure. She had cast off the aimless burden of her heart. Helen would carry her grief for only a short time, dying after surgery for a kidney ailment on April 18, 1901. The Clindining property and buildings on Third Street were purchased in 1907 from Helen's estate.

Charles remarried in 1904 and on March 30, 1912, helped carry the remains of Joseph Dubuc, Clindining's old business partner, to his grave in Normal Hill Cemetery. Leland succumbed to the effects of a stroke in 1918, a week after the end of the First World War. Evangeline outlived them all, dying in 1977, a widow since 1951.

And what of the Lewiston girls with whom Medora had entered Saint Helen's Hall? Free-spirited, eighteen-year-old Lola Timberlake, disliking the "restraints" of Saint Paul's Ladies College in Walla Walla, hid aboard an outbound train in April 1902, finally resurfacing in San Francisco. In early April 1906, Melina Saux arrived to attend Lola's marriage to Otto Kettenbach. The earthquake of April 18 postponed the nuptials. Melina sent the first telegram home from the ravaged city: "Safe and sound at Berkeley at Mrs. Ed Kettenbach's."

Sadly, none of John Clindining's little family was alive to get the good news.

10
POSTCARDS FROM OUR FATHERS

The Orchards

Now the largest section of the city, the Orchards were originally a vast agricultural development abounding with apples, apricots, cherries, berries, plums, pears, quinces, peaches, nuts, lettuce and grapes. The project was the result of an ambitious irrigation venture conceived and undertaken by Harry L. Powers at the turn of the twentieth century. After organizing as the Lewiston-Sweetwater Irrigation Company in 1905, Powers and partner Walter Burrell purchased several thousand acres of open land, platted the acreage into five-acre plots and conducted a vigorous and nationwide advertising campaign run by Richard Thain to convince prospective buyers of the land's potential.

Parcels sold quickly, but only water—a lot of it—could truly transform the arid area into a lush agricultural oasis. Powers and Burrell joined with the Lewiston Land and Water Company to build a complex irrigation system that distributed water from the Webb, Sweetwater and Mission Creeks to the fledgling development. Supplying water to the farms required millions of gallons collected from the area south of Lewiston. Two large reservoirs were excavated. Reservoir A is now known as Mann Lake and still serves the Orchards. Reservoir B was converted in the late 1950s into a recreation area called Hereth Park, named for Walter Hereth, who was the manager of Lewiston Orchards Irrigation District for many years.

However, with the planting of apple orchards throughout the northwest, the supply of the fruit soon overcame the demand, and many growers in the Orchards replaced apples with cherries. Horticulture remained the

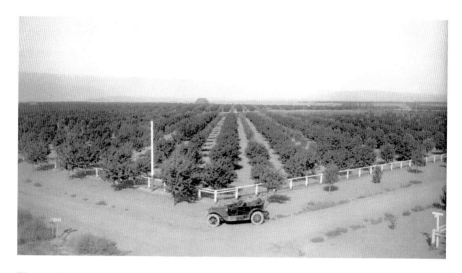

The northeast corner of Bryden Avenue and Sixth Street, circa 1915.

An aerial view of Reservoir B and Powers Avenue, circa 1926.

business of the Orchards until the 1940s, when crop failures caused by tree disease and bad weather led growers to remove the trees and sell the land as suburban lots.

ELEGIES AND BYGONE PLACES

The area maintained its own fire protection district, water system and library, and the western section had a sewer system. Nez Perce County provided law enforcement and took care of the streets. The Orchards was formally annexed into the city of Lewiston on December 16, 1969, after a bitter fight in which some residents wanted to form their own city.

The bungalow style of architecture proved very popular among the early builders in the Orchards. Characterized by broad porches and wide dormers, the style adapted well to any size of home, from the "modest cottage form or the more pretentious and costly proportions of a country villa." Architect Ralph Loring designed many of the homes. The Arthur F. Lewis home was constructed on Richardson between Fifteenth and Sixteenth Streets, a site at the far south edge of the Orchards. As with many of the homes in the area, it had a floor plan of about two thousand square feet. Screened sleeping porches supplied respite from Lewiston's hot summers, when temperatures can reach one hundred degrees Fahrenheit (thirty-nine degrees Celsius) by mid-May and hover there until late September. The costs of building a home in the Orchards before the First World War ran upward of $4,000 ($100,000).

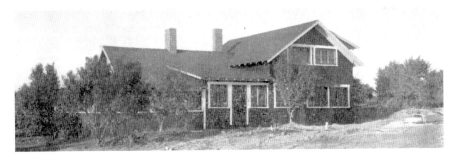

Arthur Lewis home, 1500 block of Richardson Avenue, 1913. From *Lewiston Orchards Life*.

Charles Hall home, 1220 Alder Avenue, 1913. From *Lewiston Orchards Life*.

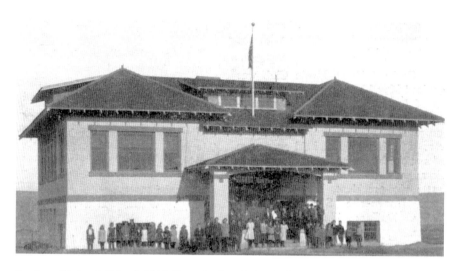

Lewiston Orchards School, 1914. From *Lewiston Orchards Life*.

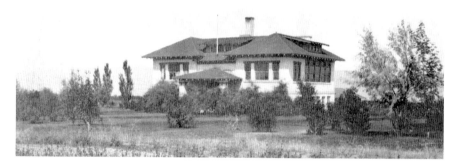

Lewiston Orchards School, 1918. *Courtesy of the Lewiston High School Archives.*

Before 1910, Orchards children had to ride in wagons or on horseback to Lewiston, where the elementary school was located on Main Street. A rapid influx of growers and their families made a neighborhood school a high priority. In 1912, the Lewiston Land and Water Company donated five acres for the site of a school. Bonds for $8,000 ($180,000 today) were authorized by a seven-to-one vote of the taxpayers, who had a fund of $3,000 ($67,000) already in the bank from a 1909 levy. James Nave designed the school, and N.R. Lee, a longtime resident of the Orchards, was awarded the contract on June 3, 1912.

Work began immediately, and about forty students attended their first classes in the school on October 28. Parents and students attended a formal dedication ceremony in the form of an open house and concert on December

6. The school originally had only two teachers—Mesdemoiselles Nina Middlekauff and Emma B. Quayle. Beginning in the fall of 1913, grades seven and eight were added and continued to be taught, at times, until World War II. From its earliest days, the school was part of the Lewiston School District, although it was well outside the city limits. Indeed, all schools in the Orchards were outside the city limits until annexation.

The new school did not have the modern amenities. Proper toilet fixtures and septic tanks were finally installed in the fall of 1915 at a cost of $2,500 ($54,000). The bathrooms were, however, outdoors. By 1917, the building had become very crowded and needed major upgrades. At a cost of $5,500 ($93,000) and using another design from Nave, the heating plant was moved from the main building to a north-side annex, to provide steam heat throughout the building, and indoor restrooms were added to the first and second floors, along with new classrooms. No more outdoor loos.

Lewiston began bussing students from the Orchards to its secondary schools soon after World War I. Enrollment at the Orchards School had increased to 170 in 1920, even though the eighth grade had been temporarily transferred to the high school in town. In 1926, major renovations began, funded by a bond of $21,000 ($260,000). The addition on the south side of the building completely changed the appearance of the school and housed four classrooms on the lower level and an auditorium on the second floor. The auditorium and stage were later divided into three classrooms when the postwar baby boom created a need for instructional space.

The stress on classroom space can be appreciated when considering that the facility was the only school in the Lewiston Orchards until 1948, when Warner School opened to students. In 1953, the school district purchased three acres next to the school for $5,000 ($40,000). A November 1954 bond election raised $290,000 ($2,300,000) for a new building, which opened to students in September 1956 and was dedicated on January 28, 1957. The new school was projected to serve for at least fifty years.

The district continued to use the building until 1971, when it was torn down, completely out-of-date and a health hazard. The only remaining piece of the old school is the "Orchards School" sign at the entrance to Orchards Elementary School. The sign originally said "Lewiston Orchards School" and dated from the 1926 renovation.

Born on June 12, 1845, Richard S. Thain was a native of Milburn, Illinois. Delivered atop a backup propeller aboard a steamer in the midst of a great storm that claimed several ships on Lake Michigan, he was named Richard after the ship's captain. The "S" stood for Samson, an

An aerial view of the intersection of Thain Road, Burrell Avenue and Twelfth Street, circa 1946.

appropriate name for a storm-born infant. In August 1862, seventeen-year-old Thain enlisted in the Ninety-sixth Illinois Infantry and saw action in twenty engagements before being discharged in July 1865. He took a bullet through his shoe and had his canteen shot off at Chickamauga (September 1863) and was struck in the leg by a bullet at Lookout Mountain (November 1863).

After the war, Thain began a long and successful career in advertising and land development and was the editor of *Agricultural Advertising*. The magazine *Irrigation Age* (November 1909) described him this way:

> *Mr. Thain, as proven by the high regard in which he is held by his colaborers in the advertising field, has gained for himself a reputation for aggressive, successful work. For more than forty-two years, in fact since present advertising methods have evolved from infancy to full maturity, Mr. Thain has maintained himself at the wave-top of the tide. His peculiar powers of inception and organization have brought to him not only the laurels of success, but also a bank account*

of no mean proportions...To be able to maintain for so long a period a steady, uninterrupted and beneficent bearing is indeed a grand accomplishment. There is a goodness about Mr. Thain which is not dependent upon his advertising qualifications. It goes beyond the knowledge of the technique of his business.

Thain retired to Oak Park, Illinois, and fully expected to live out the rest of his life at the "colony at Lewiston, Idaho, known as Lewiston Orchards," However, he succumbed after a long illness in November 1912. He and wife Emma owned ten acres of property at Warner Avenue and Eighth Street.

A large crowd assembled at Lewiston's new airport on

Richard Thain, 1909. From *Irrigation Age*.

Thain Road, circa 1915.

LOST LEWISTON, IDAHO

An aerial view showing the Lewiston airports, circa 1946. The original airport hangar can be seen in the center background, at the corner of Fourth Street and Warner Avenue.

July 11, 1932, to watch the aerial tricks of the Idaho "air-tours planes." The activities were part of the dedication of the Weeks Airport. Virgil Adair, A.R. Bails and Hobart Burns performed along with other regional aviators in formation, racing stunts and other maneuvers. In August, the management announced the construction of a new hangar at the facility located at the corner of Fourth Street and Warner Avenue. Later in the month, the twenty- by twelve-hundred-foot runway was coated with an asphalt solution. The city took control of the airport in February 1934 (*Historic Firsts* 142–43).

In March 1942, construction began on 650 acres of land set aside by the War Department for a "defense airport." That site is now the Lewiston–Nez Perce County Regional Airport. The exact cost of the project is not known, but estimates put it at $800,000–$1,000,000 ($9.8 million–$12.3 million). The airport was officially dedicated on July 19, 1944 (*Historic Firsts* 146–47).

Epilogue
AS THROUGH A GLASS EYE

Life is what happens to you while you're busy making other plans.
—John Lennon

Every person is another's butter.
—Bura proverb from Niger and Burkina Faso

David Livingstone was famous. No, I mean really famous, not like the ephemeral and capricious adulation awarded to today's motion picture, recording and athletic idols. Livingstone's notoriety stemmed from his compassion for others, lack of self-importance and dedication to take an unordinary path, what Robert Frost called "the one less traveled by." His status was almost mythical.

Livingstone was a Scottish medical missionary with a passion for exploration. So impressed were his superiors at the London Missionary Society that they wrote to him, explaining that they had several promising young men who would benefit from his wisdom and experience. They wanted to know if there were any good roads to where he was now located? Livingstone wrote back: "If you have only men who will come if they know there is a good road, I don't want them. I want men who will come if there is no road at all."

When Livingstone disappeared in 1866 on one of his expeditions, a frantic search was undertaken to find him. You know the rest of the story: how Henry Morton Stanley found Livingstone in failing health in Ujiji, on the shores of Lake Tanganyika. Not daring to touch him, Stanley uttered the

EPILOGUE

David Livingstone, circa 1865.

famous line, "Dr. Livingstone, I presume." What can local historians learn from this story? Allow me to outline a few important stumbling blocks you will want to avoid.

GROUPTHINK

Cooper's eye was splendidly inaccurate. Cooper seldom saw anything correctly. He saw nearly all things as through a glass eye, darkly.—Mark Twain, speaking of the novels of James Fenimore Cooper

Twain's broadside about Cooper's "literary offenses," although satirical, exemplifies a major challenge for amateur and professional historian alike—retelling the past without getting trapped in Napoleon's Axiom: "History is the version of past events that people have decided to agree upon." Livingstone's missionary society was not focused on the more important things. Their "eye" was too dark, and the temptation to agree was very strong, leading to what is called "groupthink," in which the desire to agree results in poor decision-making and perpetuated errors.

Alfred Sloan, former chairman of General Motors, came to the end of an important meeting with his division chairmen and did not like what he was hearing.

> *If we are all in agreement on the decision, I then propose we postpone further discussion of this matter until our next meeting to give ourselves time to develop disagreement and perhaps gain some understanding of what the decision is all about.*

A lyric to a 1927 song reads "Fifty million Frenchmen can't be wrong." Often used sarcastically, the phrase frequently justifies a point of view by

alluding to its general acceptance. The temptation to achieve consensus can throttle an honest reexamination of the facts. It is certainly acceptable for historians to disagree. Even eyewitnesses disagree, but who of us is an eyewitness to the stories we attempt to preserve? I have been a victim of this form of thinking.

Daniel Patrick Moynihan once observed: "Everyone is entitled to his own opinion, but not his own set of facts." In *Hidden History* (45–46), I told the story of a Lewiston girl who left the city after graduating high school to pursue a Hollywood career as "Julie Gibson." Every reputable resource on movie history lists her original name as Gladys Camille Soray. When *Hidden History* was launched, a colleague of mine, who is a retired letter carrier, asked if she was related to the Sorey family in Lewiston, to whom he had delivered mail for many years. Did you notice the spelling?

His question nagged at me. The answer lay somewhere. The census records for 1930 say "Sorey," but enumerators were notorious for poor spelling. Playing a hunch, I reached out to the registrar at Lewiston High School in an effort to locate Camille's transcript. Yes, the sources have all perpetuated an error that first appeared in early 1960s.

There is a moral to this story. Be careful whom you believe. The motto of the Air Force Technical Applications Center says it very well: "In God We Trust; All Others We Monitor." Conversely, be careful of what you write. Someone may just take your word as gospel.

Paradigm Blindness

Every person, family, organization, town and city settles into a comfortable way of seeing and doing things. Those routines are paradigms, patterns for perceiving the world and reacting to it. All too often, my students voiced the opinion that their town was boring. They were assessing their opportunities "as through a glass eye, darkly" and suffering what behaviorists call "paradigm blindness." A narrow vision can be devastating.

When most of us were young and someone mentioned watchmaking, we all thought of Switzerland. In 1968, the Swiss held a 65 percent market share. Ten years later, the share was 10 percent, and more than 75 percent of their workers had lost their jobs to Japanese companies who had no market share at all in 1968. How did this happen to the Swiss? It was a failure to recognize the implications of changes that would result from their own work.

EPILOGUE

In 1968, Swiss engineers brought a new idea to the manufacturers: the quartz movement watch. Management rejected it out of hand. It did not fit their paradigm. Having bought into that thinking, the designers did not even file for a patent but thought the discovery might be interesting as a novelty at the upcoming World Watch Congress. The Japanese company Seiko got a good look. I need tell you no more. Remember when "Made in Japan" was synonymous with junk? Times have changed.

The lesson is clear: Never underestimate the importance of seemingly insignificant items in the stories you hear or tell. Retracing history is much like pulling on a thread in a badly woven garment. One thread unravels others. No person, no family has lived in isolation, without connections; no event ever occurred in a vacuum.

In September 2013, I finally decided that enough was enough. I had fought to keep my old lawn green for years. Lewiston summers can be very hot and dry, and 2013 was no exception. My lawn looked terrible. My wife, Shann, was insisting that we do something about it. The obvious solution was to tear out the yard, install a sprinkler system and hydroseed the area. As the work got underway, I posted a couple of photographs on Facebook to show the ongoing project, photos that reminded our son Spencer of "no man's land" in World War I.

I received a note from a man in Illinois, saying that he had lived in our house in the 1940s and 1950s as a boy, when his grandparents owned the home. He had been enjoying the stories of Lewiston history that I was posting. He recommended the site to his cousin in Washington State. In January of this year, I posted a photo of John Douglas McConkey. Within a few hours I received a note from her: "Have historical artifacts from a minister in Lewiston. Name was McConkey. Was this man a local minister?" A box of vintage photographs, letters and certificates had languished for decades, undisturbed and disconnected from their provenance. Within a few months, I was in possession of the artifacts and able to tell a fuller story in chapter four. That is the power and joy of serendipity that comes from a little thread pulling.

Lack of Curiosity

In 1895, German researcher Wilhelm Roentgen was tinkering with a cathode tube and noticed that his photographic plates were producing mysterious

images of nearby objects. An unknown ray, which he dubbed "x," was interacting with the photo emulsions. He soon realized that the rays passed through some objects and not others. He put his wife's hand in front of the tube and exposed a plate behind it. The result was the world's first radiographic image, showing the bones of her hand and her wedding ring. Roentgen won the 1901 Nobel Prize. He was later asked what he thought when he made the discovery. "I didn't think. I investigated." His curiosity was a greater stimulus than his lack of understanding.

Roentgen was willing to suspend his disbelief. You may remember Sherlock Holmes' comment to Dr. Watson in *The Sign of Four* (1890):

Wilhelm Roentgen, 1900.

> *How often have I said to you that when you have eliminated the impossible, whatever remains, however improbable, must be the truth?*

As a historian, I constantly remind myself of what Nobel Laureate Nadine Gordimer said: "The facts are always less than what really happened." If I am not curious, I will remain only partially informed. Partially informed, I only tell important stories partially. For you math lovers, consider this: if a historian tells only one-half of the story and each succeeding historian picks up on the account and tells just one-half in turn, after the story is told five times, the end result is a mere one-thirty-second of the original facts. Does the expression "diminishing returns" sound appropriate?

EPILOGUE

Disconnect

For most readers, that word would connote a sense of emotional detachment. However, for historians it has much more permanent consequences. It can be the photo of a family with no names attached. It may be an image of an unidentified building razed, destroyed by fire or demolished by neglect so long ago that no one has any firsthand memory of it. The horizon of human experience continues to move along the timeline of history. I saw Civil War veterans on the *Ed Sullivan Show* when I was a boy. When I was a young man in college, I could still interview veterans of the Spanish-American War. One would be hard-pressed today to interview someone who truly experienced the Great Depression.

A recent television commercial advocating retirement planning asked people, "How old was the oldest person you have known?" I met a woman who reached 108 and knew of a Lewiston resident who achieved 110. A more important question is: What did I do to safeguard their life histories? Sadly, the answer is nothing, and I regret my lack of connection. As I discussed in the introduction to *Hidden History*, memory is too fragile and susceptible to confusion to leave a town's heritage to chance. Local historians can let their pasts die as literally as the people who lived it.

We end up where we began. On page nine of *Historic Firsts*, I quoted Thomas Macaulay:

> *A people which takes no pride in the noble achievements of remote ancestors will never achieve anything worthy to be remembered with pride by remote descendants.*

When the Lewiston school district opened its new high school in March 1928, visitors were greeted by a bronze plaque in the main hallway that still reads: "Education that does not enhance behavior is for naught." If this Lewiston trilogy has inspired you to become more sensitive to the duty you have to your forebears, then I will have achieved a measure of success. If you are moved to take it upon yourself to flesh out the heritage of your zip code, I will rest from my labors content. If you decide to become a tourist-for-a-day in your own town with your children or grandchildren, you will find me a satisfied historian.

INDEX

A

Adams, Charles Francis 22, 23
airport 145, 146
Alexander, Joseph 35, 47
Alford, Eugene 25

B

Barnett, Harry 89, 90
Bengal Field 91
Binnard, Abraham 16, 30, 36, 47, 105, 106, 113
Binnard, James 77
Black, George 116, 117, 118
Bouton, Ruby 122, 123
Bunnell, Charles 15, 103
Burrell, Walter 139

C

Cascade Christian College 123
Claggett, William 126
Clark, John 36
Coburn, Chester 29, 59, 60
Cole, James 63

Cooper, Thomas 19, 26
Cutter, Kirtland 13, 16, 30

D

Dent, David 23, 24

E

Elks Lodge 41, 89
Elliott, Oliver 118, 120
Erb, George 18
Euster, William 57, 59
exhumation 100, 103, 104, 105, 106, 110

F

Fairchild, Lee 61, 62, 73
Fix, John 31, 66

G

Gilman, Dudley 106, 107, 109
Goddard, Mary 125, 126
Griffits, Thomas 125, 126, 128
Grostein, Robert 14, 15, 16, 36, 45, 47, 105, 113

INDEX

H

Hereth, Walter 139
high school 22, 30, 32, 48, 49, 107, 113, 120, 132, 149, 152
Howe, Jonathan 62
Hunt, Warren 132, 135, 137

J

Jones, Robert 123
Jordan, Len 122

K

Kester, George 26
Kettenbach, Mary 49
Kettenbach, William 16, 19, 20, 49, 83
Knepper, George 21, 113, 114, 115
Knights of Pythias 102

L

Leland, Charles 132, 134, 135, 137, 138
Lewiston State Normal School 16, 18, 20, 21, 23, 48, 61, 63, 67, 68, 86, 111, 113, 117, 118, 120, 121, 123, 124
Livingstone, David 147, 148
Loring, Ralph 23, 24, 84, 141

M

Madgwick, Harry Thurston 13, 14, 15, 16, 18, 19, 20, 21, 22, 23, 24, 25, 26, 27, 28, 29, 30, 31, 32, 33
Martin, Joel 130
Masonic Lodge 14, 28, 29, 32, 41, 60, 77, 83, 95, 100, 102, 103, 110
McConkey, Anna 70, 71, 72, 73, 74, 75, 77, 79, 80, 84
McConnell, William 21, 45, 82, 113
McGrane, Catherine 95, 96
Menomy, John 82, 102, 104
Morris, Benjamin 16, 48, 115
Moxley, John 31

N

Newell, Robert 95

O

Odd Fellows 41, 67, 82, 102
Orchards School 142, 143
Osmers, Christian 38, 84
Owl Drug 38, 84

P

paradigms 149, 150
Pearcy, Edmund 62
Pioneer Park 26, 57, 67, 78, 87, 92, 100, 101, 108, 110
Powers, Harry 139

R

radar 107, 108
Raymond House 14, 16, 73, 128
Reid, James 60, 61, 67, 113, 126, 128
religions
 Baptist 61, 63, 66, 67
 Catholic 52, 78, 82, 133
 Christian Science 65, 67
 Episcopal 48, 71, 73, 80, 82, 132, 137
 First Christian 65, 67
 Jewish 30, 45, 47, 77, 87, 100, 105, 106
 Methodist 57, 59, 75, 81, 82
 Presbyterian 55, 56, 68, 81, 82
 Seventh-Day Adventist 63
 Taoist 50, 51, 52
 Universalist 19, 45, 61, 62, 63, 67, 73

S

Saint Helen's Hall 132, 133, 138
Salvation Army 64
Saux, Melina 132, 138
Saux, Raymond 14
Schlauch, Gustave 67
Scully, Matthew 31
Siers, John 125, 126

INDEX

Silcott, John 14, 49, 63
Sims, Wayne 123
Slick, Grace 90
Supreme Court Building 30, 89, 100

T

Taft, William Howard 87
Temple Theater 30, 48
Thain, Richard 139, 143, 144, 145
Thatcher, Charles 22
Thiessen, Johann 24, 25
Timberlake, Lola 132, 138
Tobin, Emma 134, 136, 137, 138
Todd, Glenn 120, 121
Turner, John 120
Tuttle, Daniel 73, 74

V

Visitation Academy 21, 54, 117, 133
Vollmer, Evangeline 48, 74, 103
Vollmer, John 16, 23, 49, 52, 74, 83, 103, 110

W

Weisgerber, Christ 26, 30, 38, 55, 103
White, Edgar 43
Wiggin, Charles 82, 102
Wildenthaler, Seraphin 16, 19, 23, 56
Williams, Ed 123

ABOUT THE AUTHOR

A widely published historian and career educator of gifted children, Steven D. Branting has been honored for his research and fieldwork by, among others, the History Channel, the American Association for State and Local History, the Association of American Geographers and the Society for American Archaeology. The Idaho State Historical Society conferred upon him the 2011 Esto Perpetua Award, its highest honor, citing his leadership in "some of the most significant preservation and interpretation projects undertaken in Idaho." In 2013, the National Society of the Daughters of the American Revolution selected Branting for its coveted Historical Preservation Medal, the first to an Idahoan.

Visit us at
www.historypress.net

This title is also available as an e-book